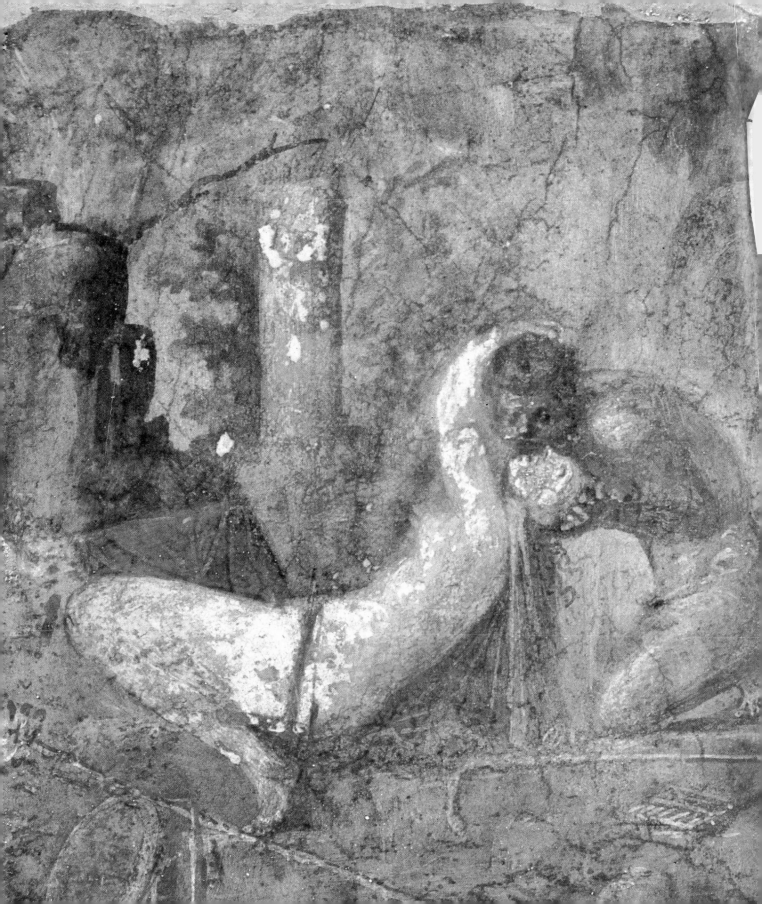

EROTICISM IN POMPEII

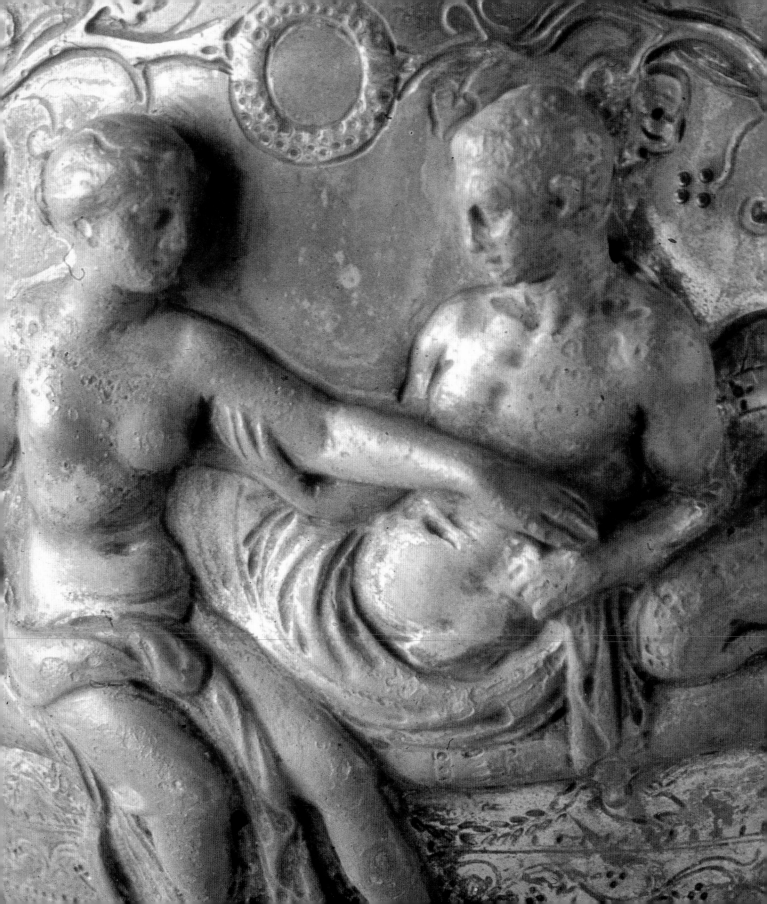

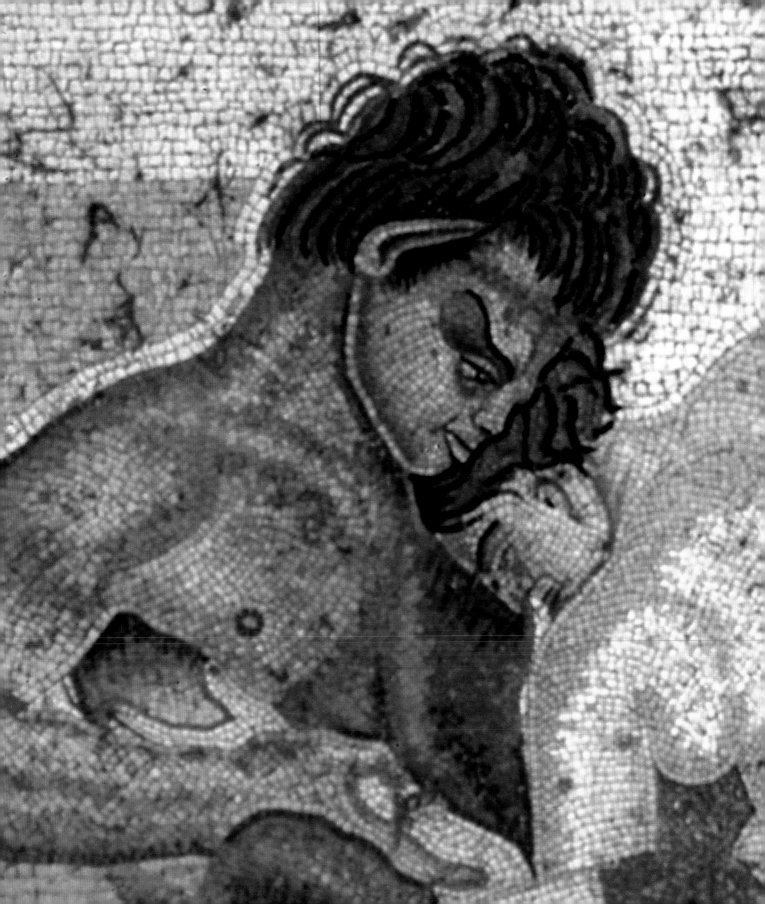

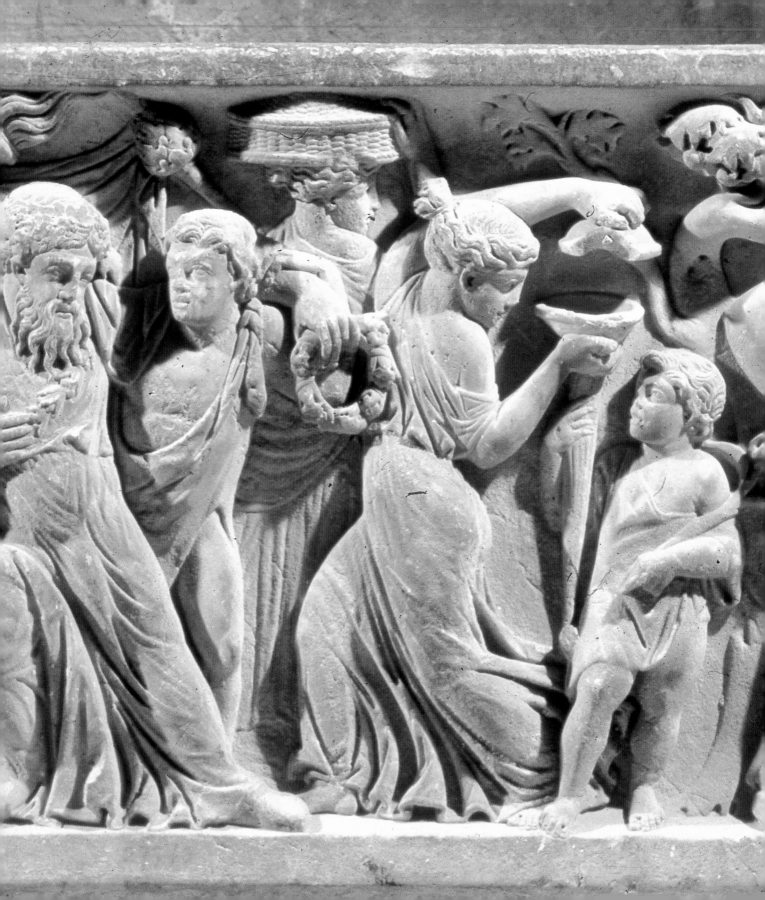

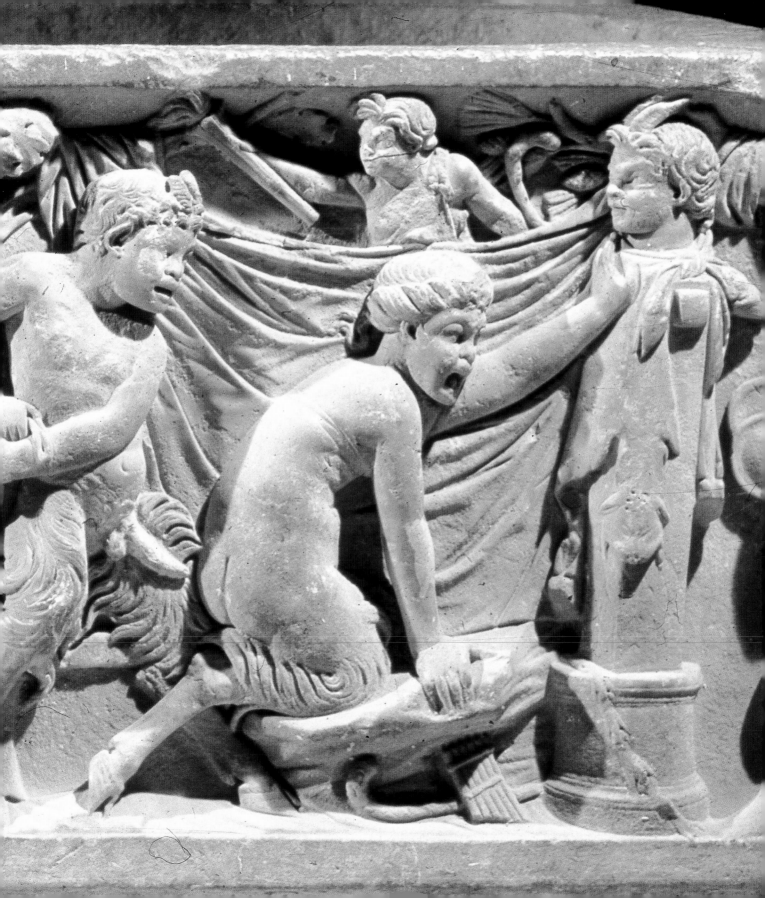

Antonio Varone

EROTICISM IN POMPEII

The J. Paul Getty Museum • Los Angeles

Antonio Varone

Eroticism in Pompeii

Translated by Maureen Fant

© 2001 «L'ERMA» di BRETSCHNEIDER
Via Cassiodoro, 19-00193 Roma - Italia

First published in the United States of America in 2001 by
The J. Paul Getty Museum
1200 Getty Center Drive, Suite 1000
Los Angeles, California 90049-1687
www.getty.edu/bookstore

At the J. Paul Getty Museum:

Christopher Hudson, *Publisher*
Mark Greenberg, *Managing Editor*

Library of Congress Catalog Card Number: 00-108442

ISBN: 0-89236-628-1

Printed in Italy

On the cover:

Pompeii. Fresco from the House of Caecilius Jucundus
Naples, Museo Archeologico Nazionale, inv. no. 110569

Photographs:

Alfredo and Pio Foglia, Naples, and the Soprintendenza Archeologica di Pompei (figs. 33, 34, 81)

Terracotta sign with depiction of extremely ithyphallic man.
From Pompeii, the house at VII.1.36.

INTRODUCTION

Eroticism is subtle magic. It is an indistinct ground between spirit and the senses where emotion is confused with temptation. Although inescapably linked to sex, it lies at the opposite pole of crude sexuality. Eroticism has a conspicuously cultural, but very sophisticated, dimension, and transgression is one of its most powerful allies. Its natural place of origin is uniquely cerebral and thus intimately tied to each individual's own history and, more generally, to the cultural history of the society to which he or she belongs. It may therefore be surprising to discover that eroticism, at least as we are using the term, was probably not very widespread in the ancient Roman world.

In a society that knew neither the doubt of sin nor the prurience typical of our age, sex was practiced with far greater simplicity, spontaneity and naturalness, albeit often with crudity. Fewer were the occasions, whether in a merely allusive or outright prohibitive context, in which desire met seduction to spark the passage from sexual play to an erotic atmosphere.

People of the Roman world did not need to mince words or to don mental veils to cover the nudity of their humanity. If we do not want to confuse eroticism with the simple call of the senses, we realize we are moving in a very different sphere. The Romans practiced, without ever recognizing them as such, what we consider perversions, and did so with insistence and apparent innocence. Even the notion of the obscene as we use the term today did not exist, on the same level as morbidity, in actions that present-day sensibility would consider decidedly dirty.

Consequently, many of the "situations" that we generally and immediately sense as strongly erotic were to the Romans utterly without that very particular emotional charge engendered by the blending of intense desire, seductive offer and a sense of the forbidden in the same situation.

The fact remains—beyond a bogus "official" morality that held certain behaviors reprehensible, although few in fact refrained from them—that on occasion extreme situations were sought. These should be considered less as the unbridled pursuit of hedonism or satisfaction

of the senses, and more as a separate component of their own, unlikely to be definable, now as then, except as heavily characterized by eroticism.

Thus Martial recounts of Lesbia, in a felicitous epigram (I.34.1–4): "By unattended and open doors, Lesbia, you sin with your lovers, nor do you hide your acts. Greater is the pleasure you get from him who peeps at you than from the man with whom you are united. Only that pleasure is enjoyable to you that is also made known to others."

For her part, Messalina, shameless wife of the emperor Claudius, certainly had no problems satisfying her sexual yearnings inside the palace, in the manner and with whom she pleased. Her desire to indulge in the most forbidden acts of lasciviousness conceivable for an empress of the world can only be considered as supreme erotic impulse. In fact, Juvenal (6.116 ff.) informs us that "as soon as his wife thought that he was asleep, this imperial whore put on the hood she wore at night, determined to prefer a cheap pad to the royal bed, and left the house with one female slave only. No, hiding her black hair in a yellow wig she entered the brothel, warm with its old patchwork quilts and her empty cell, her very own. She obligingly received customers and asked for her money, and lay there through the night taking in the thrusts of all comers. Then when the pimp sent the girls home, at last she went away sadly, and (it was all she could do) was the last to close up her cell."

Nero, on the other hand, who could already dispose of the life of men, wanted to dispose of Nature as well, in an erotic delirium that exalted itself in the public exhibition of a power without limits. Not satisfied with intercourse in the active or passive role with other men, he even wanted to emasculate one, Sporus, so that he could marry him, as a woman, in a formal ceremony (Suetonius, *Life of Nero* 28.1 f.). Such ceremonies—we possess not entirely vague descriptions (e.g. Martial, *Epigrams* XII.42)—while lacking effective legal significance, are nevertheless indicative of the phenomenon of the life *en travesti*, which at the time enjoyed a certain vogue. Then there was Tiberius, with his predilections for pure eroticism, at least as told by Suetonius (*Life of Tiberius* 44.1)—far stronger stuff than our present-day sensibilities can

> BY UNATTENDED AND OPEN DOORS, LESBIA, YOU SIN WITH YOUR LOVERS, NOR DO YOU HIDE YOUR ACTS. GREATER IS THE PLEASURE YOU GET FROM HIM WHO PEEPS AT YOU THAN FROM THE MAN WITH WHOM YOU ARE UNITED. ONLY THAT PLEASURE IS ENJOYABLE TO YOU THAT IS ALSO MADE KNOWN TO OTHERS.
> MARTIAL, *EPIGRAMS* I.34.1–4

stand. They were judged absolutely nauseating, in their singular perversity, even by those of the day, who measured on a far different scale from ours.

It is not, however, to be believed that eroticism appeared in antiquity only in such paradoxical forms, just as it is not to be believed that love did not know anxiety, torment, jealousy, sensuality, passion, poignant desire and all the atmospheres of seduction, as countless inscriptions scratched on the walls of Pompeii attest.

The purpose of this book, then, is to examine, within a Pompeian universe that was incredibly varied and heterogeneous in this respect, those manifestations of thought to be gleaned from the analysis and interpretation of archaeological and epigraphic documents that shed light on the way eroticism appeared in the Vesuvian city. Unfortunately the mindsets or preconceptions on the subject that we moderns have cultivated are not easily discarded to permit an impartial critical evaluation. Two thousand years of evolution in thinking have passed and aspects of sexuality have been framed within philosophic, moral and religious systems that, while differing one from another, in more or less broad measure influence our approach to the issue. To free this research as much as possible from the snares of our own mentality, we will, where feasible and appropriate, quote excerpts from authors of the day, especially Martial, who established himself in Rome in 64 and whose books were published in the years immediately following the destruction of Pompeii. He thus helps us view the Pompeian scene better in relation to the spiritual and cultural climate of the time. The excerpts provide homogeneous points of comparison for the understanding of the various phenomena, in the light of how they looked or at least came to be noticed. For other Augustan authors such as Horace, Ovid or Propertius, comparison does not seem inappropriate. Much of the Pompeii that we know dates exactly to the years of their activity. It can be difficult for us moderns, used to the overwhelming succession of discoveries and innovations that radically change our systems of living and thinking over the brief span of a few years, to imagine that a century can be a homogeneous arc of time. Nor do I intend to maintain that it is. Appreciable differences have certainly been grasped between the cultural climate and the expectations of the earliest years of the Empire, and those of the reigns

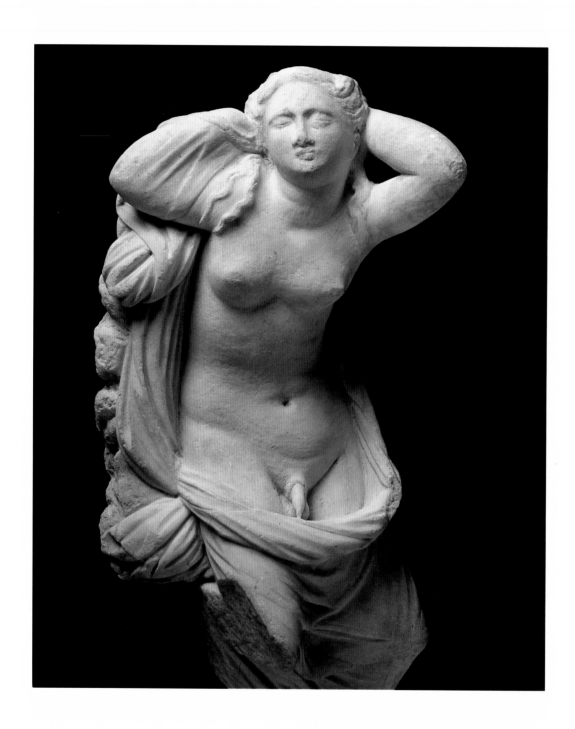

Marble statue of Hermaphrodite.
From the House of Octavius Quartio (III.2.2). First century A.D.
Pompeii, inv. no. 3021.

of Claudius and Nero or of the Flavian dynasty. In the historical prospective, however, the first century of the Roman Empire appears as a compact period, intent on the total rearrangement of the world into an established order and the affirmation of classes emergent in the social order. All in all, however, regarding the central topic of our attention, reversals of perspective or radical transformations over the course of those years cannot be detected, while it is possible to glimpse clearly a certain evolution of the social mores.

Citing Ovid with Martial, our intention is not at all to reduce the discussion into an undifferentiated age, but rather to let the reader see, even within the evolution and differentiation present in the period, the underlying constants in the way people of the time felt and acted. Let the reader accordingly approach the sources with caution and discernment.

The reader should also bear in mind that these pages are intended only as a guide, or rather an incentive, to help open a window of direct dialogue with the ancient world on the topic. He or she should therefore not regard the orientations proposed here as indisputable truths.

We all know how difficult and mysterious it is to delve inside the human spirit, even in contemporary situations and contexts with which we are completely familiar. We can thus be well aware of how our assessments of men and times now far distant, reckoning more with the measure of thought than that of time, must necessarily be viewed exclusively as attempts to gradually approach the truth. In no case are they to be considered as completely accurate representations or confirmed likenesses.

Thus the reader should consider his or her encounter with the author in these simple pages merely as preparatory to another, fundamental, encounter, that with ancient people. The reader who manages to understand their language will be able to tap directly into them to gain knowledge, in this and in other fields, of the fundamental identity of the problems, of the aspirations and of the human urges in space and time, despite how very different they appear.

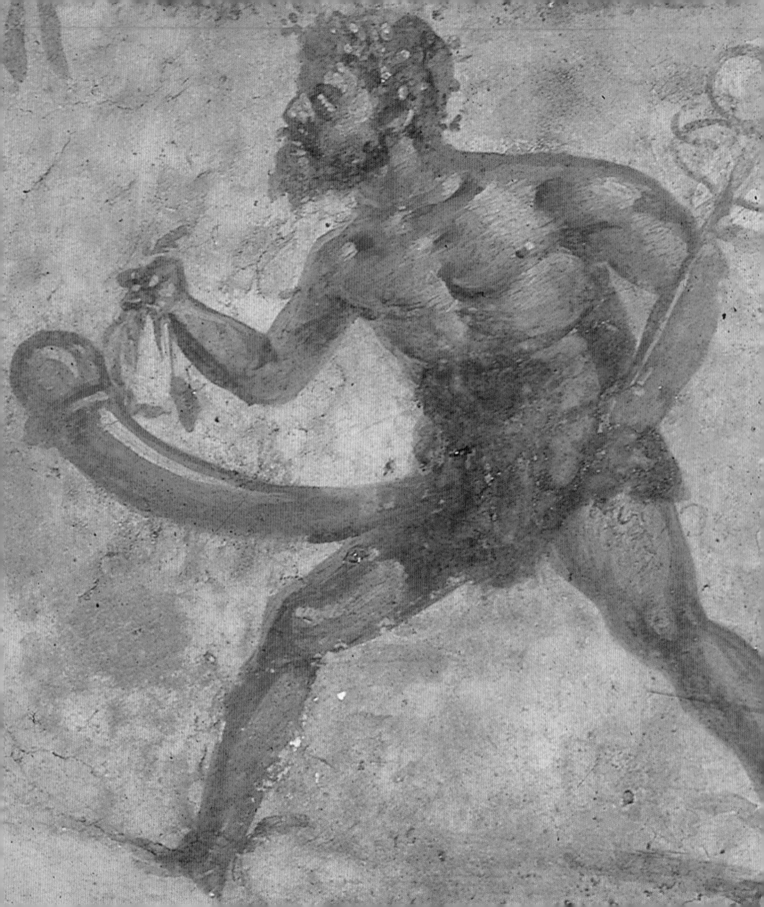

NON-EROTICISM

To be able to understand fully the erotic characterizations that can be described in the Pompeian universe, we will first have to clear the field of a series of possible misapprehensions, manifestations that might seem erotic only to modern eyes. Some finds may look to us as though they have a very strong erotic component, but to ancient eyes they bore completely different meanings and connotations.

THE DEPICTION OF THE PHALLUS

First of all, let us say that depictions of phalli found over and over in many different forms on street corners, shop signs, bronze fittings, in paintings and even on everyday objects had no erotic meaning (Figs. 1, 3–13). On the contrary, these images respond to completely different needs, a far cry from any sort of erotic context.
They are obedient to a need of nature, we would say today, which is at least magic, if not actually spiritual and even religious, as we must sometimes doubtless acknowledge.

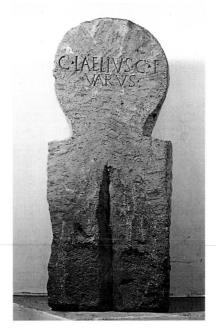

In the Sarno valley, the sign of the phallus is found even on funerary monuments, where it is invoked to symbolize the *Genius* of the deceased, or rather that vital generative force that survives him even after death, representing the continuation of his individuality beyond the decay of the flesh (Fig. 2). Priapus, over-endowed and oversexed by definition, is a god after all. His effigy was placed in gardens to protect them (Figs. 14–18). As the manifest image of the fertility of nature, he safeguarded the

1. Painting on plaster of ithyphallic Mercury bearing, with good auspices, a pouch full of money.
From Pompeii, to the right of the entrance to the bakery at IX.12.6. Fourth Style. ca. A.D. 45–79. Naples, Museo Archeologico Nazionale, unnumbered.

2. Grey tufa funerary *cippus* (tomb marker) of C. Laelius C.f. Varus.
Note on the base the large concave phallus, cut out with a deep wedge-shaped incision, and the attributes, also in negative, obtained by superficial roughing out of the stone.
From near Sarno. Mid-first century B.C. Nocera Inferiore, Museo dell'Agro Nocerino, prov. inv. no. 11594.

garden's fruits, warding off petty thieves, upon whom, if caught, he would inflict the homosexual punishment. Venus Physica, tutelary goddess of Pompeii, symbolizes the germinative force of nature itself in her encouragement of the propagation of life in all its forms, a strictly religious concept.

And yet one cannot fail to recognize the evident magical significance of the representation of the phallus on objects and signs, which thus linked it more to the sphere of superstition than to that of eroticism. Its apotropaic powers made it the favorite motif for amulets to ward off the *fascinum*, the evil eye. Obviously, the ancients perceived such depictions very differently from the way we would. They were not imbued with any obscene meaning or licentiousness, since they could be calmly displayed inside the home, in front of children, guests and conscientious mothers.

In the private baths in houses belonging to leading citizens (Fig. 19), mosaic pavement decorations sometimes contain aquatic scenes in which sexually excited figures swim among marine animals. Again, these scenes should not be considered erotic; they should rather be seen as the integration of the human element, supplied with its

 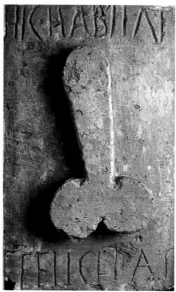 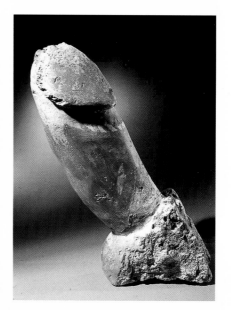

3. Shop sign.
Depiction on clay tile of four phalluses with a bottle in the middle. From the *taberna lusoria* at VI.14.28. First century A.D.

4. Red painted sign to be set into wall.
With phallus in bas-relief and the words: *Hic habitat / felicitas* (*CIL* IV 1454). From Pompeii, over the oven in the bakery annexed to the House of Pansa

(VI.6.18). A graffito on the counter of the *caupona* (inn) at I.11.2, probably next to drawing of a phallus, reads: *Bonus deus / hic abitat in do/mo / Act(i)* (*CIL* IV 8417). Naples, Museo Archeologico Nazionale, inv. no. 27741.

5. Large phallus in grey tufa with red paint, to be set into wall.
From Pompeii, *insula* 5, *Regio* IX. First century B.C. to first century A.D. Naples, Museo Archeologico Nazionale, inv. no. 113415.

procreative force, in the flow of nature, represented by that vital and vivifying element par excellence, water. This is in addition to any anecdote or narrative—unknown to us, in any case—that they may depict.

More open to debate, however, is an illustration, again on bath mosaics, of slaves with extra-large penises, such as the one at the entrance to the *caldarium* in the House of Menander (Fig. 20). In fact, in the work of the poets of the day, it is not rare to stumble upon chuckling expressions of satisfaction regarding the super-endowed, so much the more when they attend the baths and are necessarily nude and thus open to common admiration. Martial, for example, repeatedly makes such men protagonists of his compositions (*Epigrams* IX.33; see also XI.51, XI.63, XI.72 and VII.14,9–10): "Did you hear approval rise thunderously from the baths? You can be sure Maro's huge cock has appeared."

The verses leave little doubt how the Roman world regarded such endowments. That type of exaltation can border on worship, suggesting parallels in religious rites or in those of esoteric initiation, the prerogative of the girls. Even before the famous painting

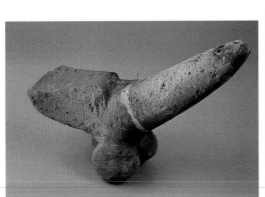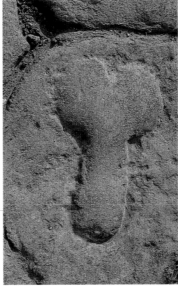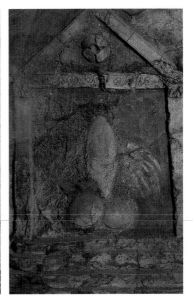

6. Large phallus of grey tufa with traces of red paint, to be set into wall.
From the alley between *insulae* 14 and 15, *Regio* I. First century B.C. to first century A.D. Pompeii, inv. no. 11940.

7. Volcanic stone from street paving with phallus carved in bas-relief.
First century B.C. Pompeii, via dell'Abbondanza.

8. Sign on vat.
Depiction of winged phallus in a small temple.
From the fuller's shop at IX.7.2. First century A.D.

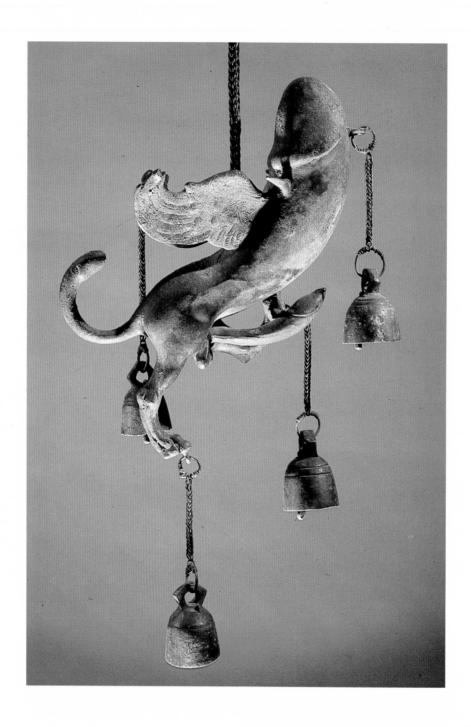

9. Bronze tintinnabulum (wind chime) shaped like a stylized phallus in the form of an ithyphallic rampant griffin.
The sound of the little bells in the wind kept away the forces of evil. From Herculaneum. First century A.D. Naples, Museo Archeologico Nazionale, inv. no. 27831.

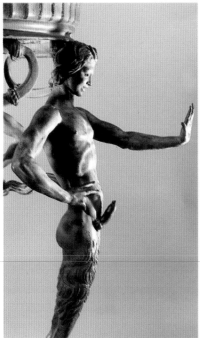

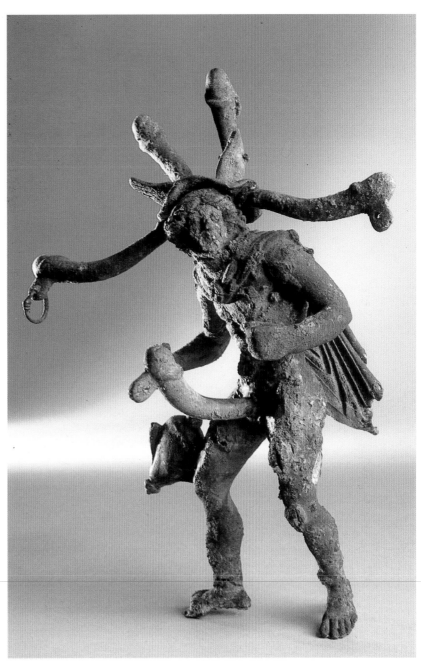

10a. Bronze tripod with legs in the form of ithyphallic fauns.
An exceptionally fine domestic object. From Pompeii, *praedia* of
Julia Felix (II.4). Probably first century B.C. Naples, Museo Archeo-
logico Nazionale, inv. no. 27874.

10b. Detail. Naples, Museo Archeologico Nazionale, inv. no. 27874.

**11. Incomplete bronze tintinnabulum depicting extremely
ithyphallic Mercury originally bearing a pouch in his left
hand.**
The phalluses on the *petasos* (winged helmet), facing the four
directions, ensured 360 degrees of protection. Naples, Museo
Archeologico Nazionale, inv. no. 27854.

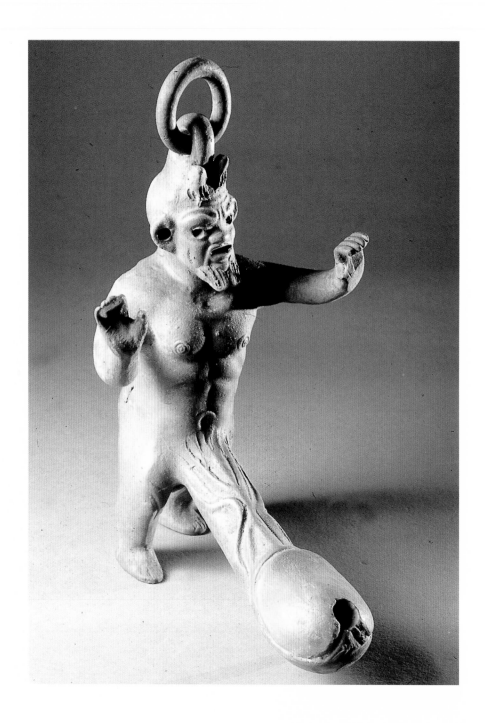

12. Hanging terracotta oil lamp in the form of an ithyphallic Pan.
From Pompeii. First century A.D. Naples, Museo Archeologico Nazionale, inv. no. 27869.

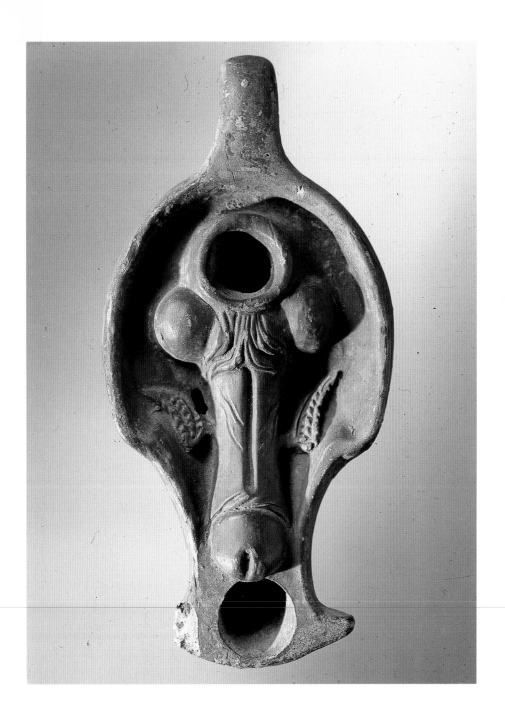

13. Single terracotta oil lamp with winged phallus in relief on the disk.
From the Borgia collection. Augustan. Naples, Museo Archeologico Nazionale, inv. no. 27867.

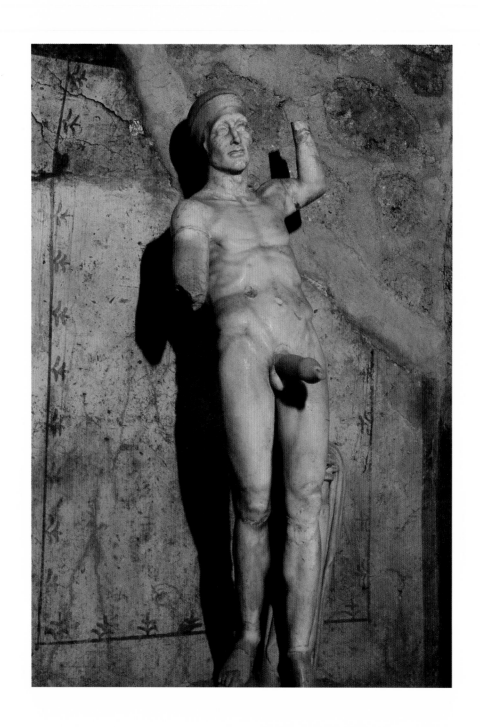

14. Fountain figure of Priapus.
Originally in the garden of the house.
Water spouted from the phallus. First century A.D.
Pompeii, House of the Vettii (VI.15.1).

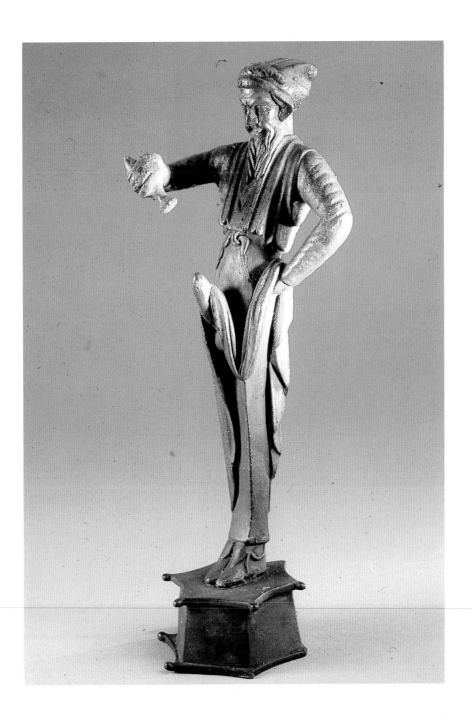

**15. Bronze statuette, on small star-shaped base, depicting
Priapus sprinkling his phallus with essences.**
From Herculaneum. First century A.D. Naples, Museo Archeologico
Nazionale, inv. no. 27731.

16. Fresco with depiction of biphallic Priapus on pedestal in rustic setting.
Probably A.D. 72–79. Pompeii, north wall of the brothel (VII.12.18), central section.

17. Fresco with Priapus.
Priapus holds up his clothing to contain the fruits of the harvest, exposing his large erect member.
Vespasianic. Pompeii, pillar of the summer *triclinium* of the house at II.9.1.

18. Priapus weighs a money bag against his penis; in the foreground is a basket of fruit.
Fourth Style fresco. ca. A.D. 45–79. Pompeii, House of the Vettii (VI.15.1), fauces.

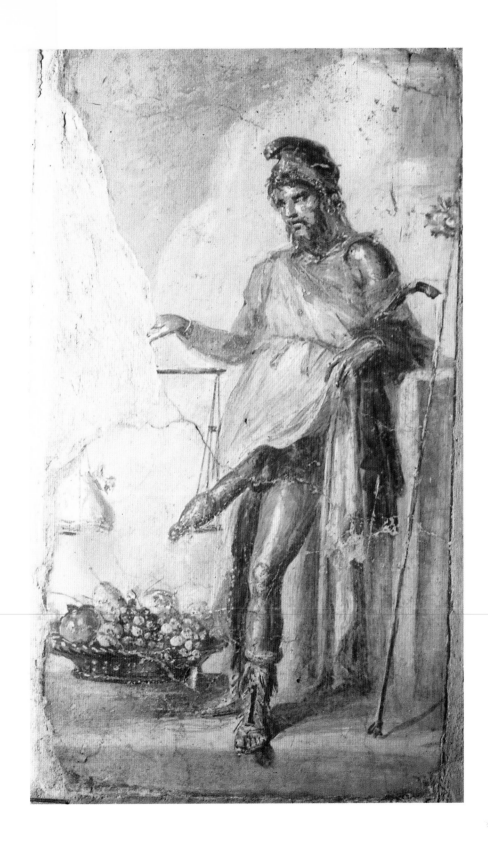

of the revelation of the phallus in the life-size painted frieze of the Villa of the Mysteries (discussed on pp. 104-105), we hear again from Martial (XI.63): "As enormous a column dangles between the legs of Titius as the one that receives the cult of the virgins at Lampsacus."

Still, it does not seem that such depictions should be regarded as executed with the intention of stirring the libido. In the mosaic in the House of Menander the servant carries two *unguentaria* of distinctly phallic form, as if to stress the primary function that is visually accorded in the scene to the bath attendant's penis. Study has shown how the baths were considered by the ancients as places in which it was easier to succumb to negative influences, hence the need for a preventive remedy, especially at the entrance, to impede the passage of the malefic forces. In keeping with the fashion of the day, projected toward the Nilotic world, and the customs then considered elegant, such as the use of Negro slaves to serve the household, in the bath of that well-to-do family's house the apotropaic purpose was achieved artistically through the figure of the super-endowed Ethiopian servant rather than with the usual exhibition of the protective phallus.

It would thus be a mistake from a modern viewpoint to read lasciviously

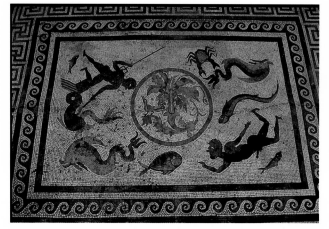

provocative intentions into that figure, to imagine erotic diversions that the mistress or the master indulged in within their domestic walls.

19. **Mosaic with marine scene and ithyphallic man swimming.** Advanced Second Style. ca. middle of the first century B.C. Pompeii, House of Menander (I.10.4), *caldarium*.

20. **Mosaic 'carpet' with ithyphallic servant bearing perfume flasks in the form of a phallus.** Late Second Style. ca. middle of the first century B.C. Pompeii, House of Menander (I.10.4), entryway to the *caldarium*.

As enormous a column dangles between the
legs of Titius as the one that receives the
cult of the virgins at Lampsacus.

MARTIAL, *EPIGRAMS* XI.63

IRONIC DEPICTIONS AND PARODIES

In analyzing the Pompeian universe we should also never forget that fundamental component of the human personality, irony, the seductive salt of life. The ancients knew how to cultivate and utilize that attitude with blithe simplicity at least as well as we do.

Irony is the key to fully understanding the true meaning of depictions that, away from their context, could otherwise strike us as unequivocally erotic, or sexually stimulating. It is, however, not always easy to appreciate this.

Parody, for example, is evident in scenes that openly tend to inspire hilarity, joking—and this is the right light in which to see them—about love and its various manifestations. Good examples are depictions like that of Pan who, coming upon Hermaphrodite (Figs. 21–22), recoils in consternation, or the monstrous, gigantic Polyphemus, clumsily grappling with the pale and tender Galatea, evoking the eternal theme of the collective erotic imagination that we call "beauty and the beast" (Fig. 23).

Less evident, however, is the parody in some painted scenes where strong erotic connotations that, although they leap to the eye, are tempered by a quite different, often

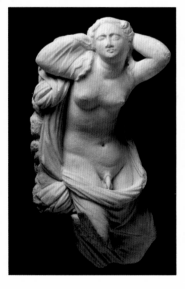

21. Marble statue of Hermaphrodite.
From the House of Octavius Quartio (III.2.2).
First century A.D. Pompeii, inv. no. 3021.

22. Wall painting of Pan recoiling at the revelation of Hermaphrodite's bisexuality.
From Pompeii, House of Epidius Sabinus (IX.1.22). Fourth Style. ca. A.D. 45–79. Naples, Museo Archeologico Nazionale, inv. no. 27700.

humorous, vision. This is the case, for example, of the banquet scenes in which deformed pygmies perform complicated sexual acrobatics (Figs. 24, 35, 36). The intention is not erotic; that is, the scene does not intend to recount the act suggestively, but rather to make fun of the diversity of those creatures, according to the fashion of the epoch, engaged in the sexual act in a way perceived as decidedly satiric, given their physiques.

It is not, of course, our intention to make judgments, inevitably based on our own ethic, on such behavior, and we shall refrain from doing so

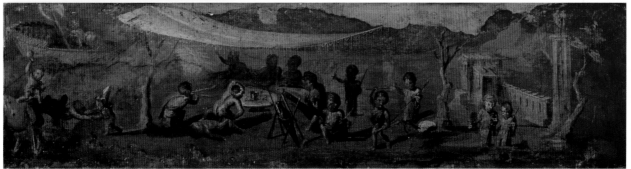

regarding sex or other topics. On the other hand, we are aware that Roman imperial society, with its mania for pursuing monstrous curiosities, knew no limits, to the point of setting up make-believe wars (with tragically real consequences) merely for the thrill of watching rivers of blood gush, making death itself into a spectacle.

As authentic as it may be, the satiric intent in scenes of disturbing sexual crudity is not at all transparent to our eyes, especially in those recently found in the complex of the Suburban Baths, outside the Porta Marina, along the street that led toward the port

23. Polyphemus and Galatea.
From Pompeii, exedra (15) of the House of the Ancient Hunt (VII.4.48).
Fourth Style. ca. A.D. 45–79. Naples, Museo Archeologico Nazionale, inv. no. 27687.

24. Nilotic scene with pygmy couple having sex during an open-air banquet.
From Pompeii, peristyle of the House of the Physician (VIII.5.24).
Fourth Style. ca. A.D. 45–79. Naples, Museo Archeologico Nazionale, inv. no. 113196.

25. Detail of the wall decoration with erotic scenes associated with numbered boxes.
Fourth Style. Probably Neronian, with Vespasianic overpainting.
Pompeii, *apodyterium* of the Suburban Baths, south wall.

(Figs. 25–32). The explicit depiction of complicated group sexual acrobatics, in addition to the detailed illustration of various positions and amorous practices in paintings found in the *apodyterium* (changing room), had at first suggested that, if the bath complex also included a hotel-restaurant on the upper story—as was suspected by the first illustrators of the only partially excavated structure—those returning from long periods at sea may have been offered other forms of hospitality, as exemplified in the pictures at the entrance to the rooms of the baths. The archaeologist who found these pictures has, however, enabled us to correct this false impression, thanks to her careful analysis of the archaeological context. It has thus been possible to establish that each individual scene of a particular sexual activity was matched to a picture of a container for clothing numbered from I to XVI, which must have corresponded to a real container, resting on a shelf, in which the client could place his belongings before going to take his bath.

In various parts of the Roman world, not including Pompeii, little coin-like disks have been found, with a number from I to XVI on one side and an erotic picture on the other. In the antiquarian tradition of the seventeenth century, these tokens were known as *spintriae*, which is a word that the Latins used for prostitute. This is probably a misinterpretation of the term as used by Suetonius (*Life of Tiberius* 43), which took it to refer to particular erotic positions. Martial may have been referring to these when he says (*Epigrams* VIII.78) that Domitian showered the people with *lasciva nomismata*, lewd coins, when celebrating a triumph. Still much debated is why such tokens, first of lead, then of bronze, with official characteristics, in that they are produced by a mint, bore this type of image. Some have suggested that they might represent a sort of counterstamp with a precise economic value, to use in the brothels where, according to an item in Suetonius (*Life of Tiberius* 48) not elsewhere confirmed, coins bearing the effigy of the emperor could not be used. That would explain why such images were incised on them.

Other uses cannot, however, be ruled out; they may have been gaming pieces, for example. In any case, some *spintriae* do not bear erotic images, but only the heads of

26. Scene of coitus from behind.
Fourth Style. Probably Neronian, with Vespasianic overpainting.
Pompeii, *apodyterium* of the Suburban Baths, south wall.

27. Scene of fellatio.
Fourth Style. Probably Neronian, with Vespasianic overpainting.
Pompeii, *apodyterium* of the Suburban Baths, south wall.

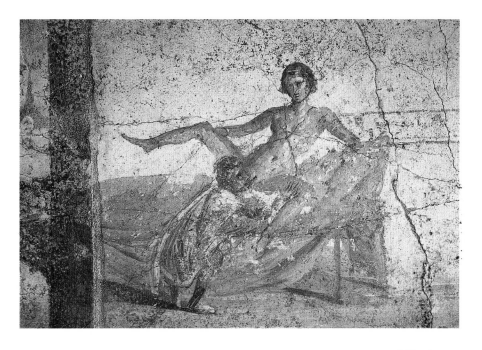

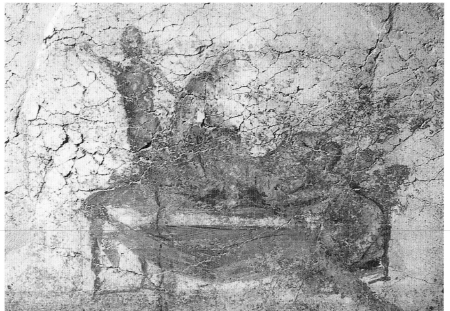

28. Scene of cunnilingus.
Fourth Style. Probably Neronian, with Vespasianic overpainting.
Pompeii, *apodyterium* of the Suburban Baths, south wall.

29. Scene of foursome making love.
Fourth Style. Probably Neronian, with Vespasianic overpainting.
Pompeii, *apodyterium* of the Suburban Baths, south wall.

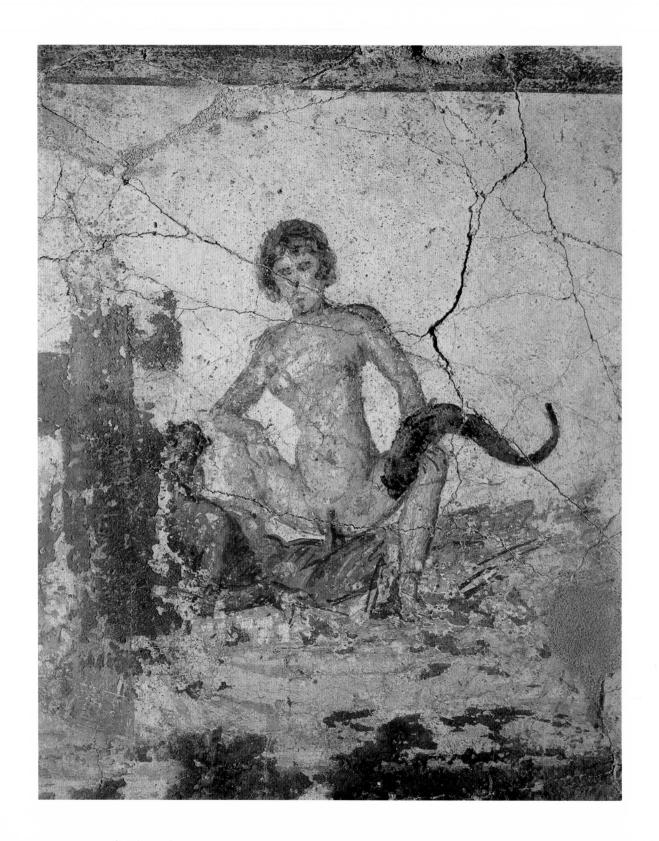

30. Painted sex scene with the woman astride the man.
Fourth Style. Probably Neronian, with Vespasianic overpainting.
Pompeii, *apodyterium* of the Suburban Baths, south wall.

31. Depiction of a "poet" afflicted with hydrocele.
Fourth Style. Probably Neronian, with Vespasianic overpainting.
Pompeii, *apodyterium* of the Suburban Baths, south wall.

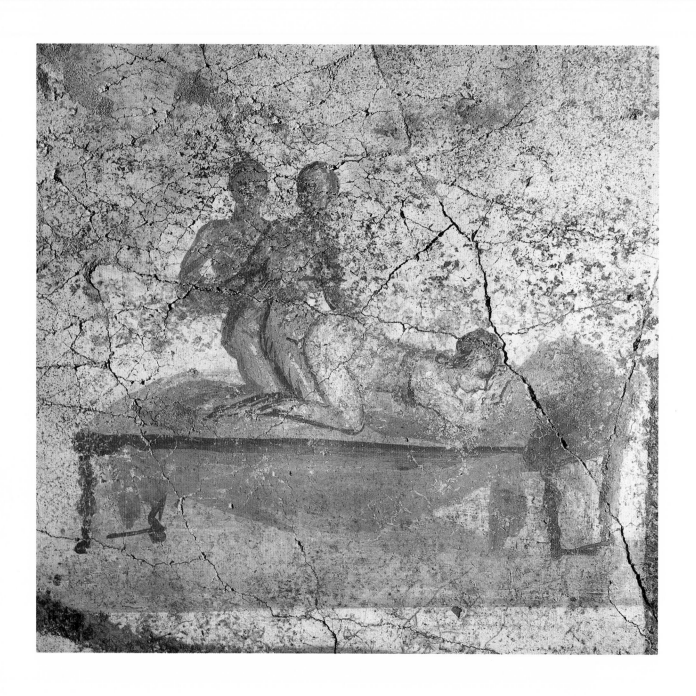

32. Painting of a ménage à trois.
Fourth Style. Probably Neronian, with Vespasianic overpainting.
Pompeii, *apodyterium* of the Suburban Baths, south wall.

unrecognizable figures, in addition to the numeral on the reverse, which thus seems to be the business side of the object. It is food for thought that two almond-shaped bone objects found at an unspecified site at Herculaneum both bear the numeral XII; one also has a hole by which it could have been hung as a pendant, the other a scene of intercourse with the woman astride the man, further expanding the range of possible comparisons (Figs. 33–34). The analogy with the pictures and the related numerals from the changing room of the Suburban Baths is, however, certain. We could even postulate that *spintriae*, which in addition to a number bore a depiction of the same position or the same erotic scene represented in painting, were given as tokens to customers depositing their clothing in the container of that number, but that would be speculation.

What counts, however, is that, apart from the functional use of such tokens in the changing room—which is, after all, conjecture—the erotic scenes, whose humorous and satiric intent at this point is clear, provided an amusing way for the public, even the completely illiterate, to remember where they had left their clothes.

These scenes still seem to represent a manual of sexual positions in a crescendo of salaciousness and boldness, considering the formally dominant attitude in relation to certain sexual practices. Hence we may take as emblematic the figure of the poet suffering from hydrocele (enlarged scrotum) (Fig. 31) at the end of the series, as an interval before the next sequence on the other wall, where the numbers are preserved but not the pictures. Martial's pungent epigram in which the similarly deformed Fabianus is caricatured comes to mind (XII.83). It is as if the figure were included to illustrate the

33. Almond-shaped pendant of worked bone, with sex scene with the woman astride the man.
First century A.D. Herculaneum, inv. 2587 (Photo S.A.P.).

34. Almond-shaped pendant of worked bone, with hole and the numeral XII.
First century A.D. Herculaneum, inv. 2584 (Photo S.A.P.).

various possibilities of differentiation of ever more complex and "deviant" erotic games from the formal sensibility of the age, probably singing their praises. Certainly Ovid did so superbly with regard to the positions that a woman should assume when giving herself in traditional coitus, and so had other poets, following the Hellenistic tradition, "citing ways to make love with five people or more in a chain," according to the same expressed recollection of Martial (XII.43, esp. ll.8–9). It is probable that anecdotes circulated at the time apropos of such "catalogues" and it is thus evident at this point how such portrayals, though they had their practical uses, were viewed both by the person who commissioned them and by the user more as stimuli to mirth and witticisms than to desire.

The bath was a relaxing time of the day. It was thus most agreeable that the sexual reference that leapt to the eye of the user upon entering the building offered him an occasion for play and laughter. Since the Romans often associated going to the baths with the idea of sex, for the physical and psychic benefits it brought and as a purely enjoyable interlude, we should certainly not be surprised, as we gather from some ancient authors (e.g. Martial XI.47; Ovid, *Ars amatoria* III.639 f.; Cicero, *De officiis* 1.35; and see also *Digest* III.2.4.2 and the ambiguous testimony of Martial III.93 14 f.), if the baths also became a place of enticement or, to put it bluntly, of prostitution. In fact, in the Vesuvius area it is not rare to find graffiti in public baths that explicitly record sexual encounters that took place there (*CIL* IV 10675, 10677, 10678, from the Suburban Baths of Herculaneum; *CIL* IV 760 with addenda, p. 196, quoted below, from the Stabian Baths of Pompeii). This is, however, a quite different matter. Regarding sex in this case, the pictures winked mischievously, certainly, but were not a call to eroticism.

In other cases, in painted scenes of life on the Nile, in keeping with the passion for Egypt in vogue in the early Empire, it is not rare to come across figures devoted to complicated amatory practices (Figs. 35–36). Here too, however, more than causing an erotic response, the artist was concerned with characterizing the serene enjoyment of life, as it flowed placidly—in

the collective imagination of the epoch—along the banks of the Nile, where the pygmies fighting with crocodiles and hippopotami represented a diversion more than a danger.

As we can see, eroticism did not characterize many manifestations to which we, with our sensibilities, would have attributed a different intent. Even the risqué scenes in the Suburban Baths, which to our eyes appear as supreme examples of erotic brazenness, were regarded by their contemporaries as merely superbly ironic cartoons, more likely to provoke laughter than lust. Sex was considered neither sinful nor shameful and could be freely displayed or discussed.

35. Fresco with Nilotic scene.
A pygmy couple has sex on a floating platform, while a third guides the raft through a "forest" of mushrooms toward a hut in the form of a little cage.
Fourth Style. ca. A.D. 45–79. Naples, Museo Archeologico Nazionale, inv. no. 27702.

36. Detail of fresco with Nilotic scene.
A ménage à trois of pygmies in a boat. From Pompeii, *pluteus* of the *viridarium* of the House of the Quadrigas (VII.2.25).
Fourth Style. ca. A.D. 45–79. Naples, Museo Archeologico Nazionale, inv. no. 27698.

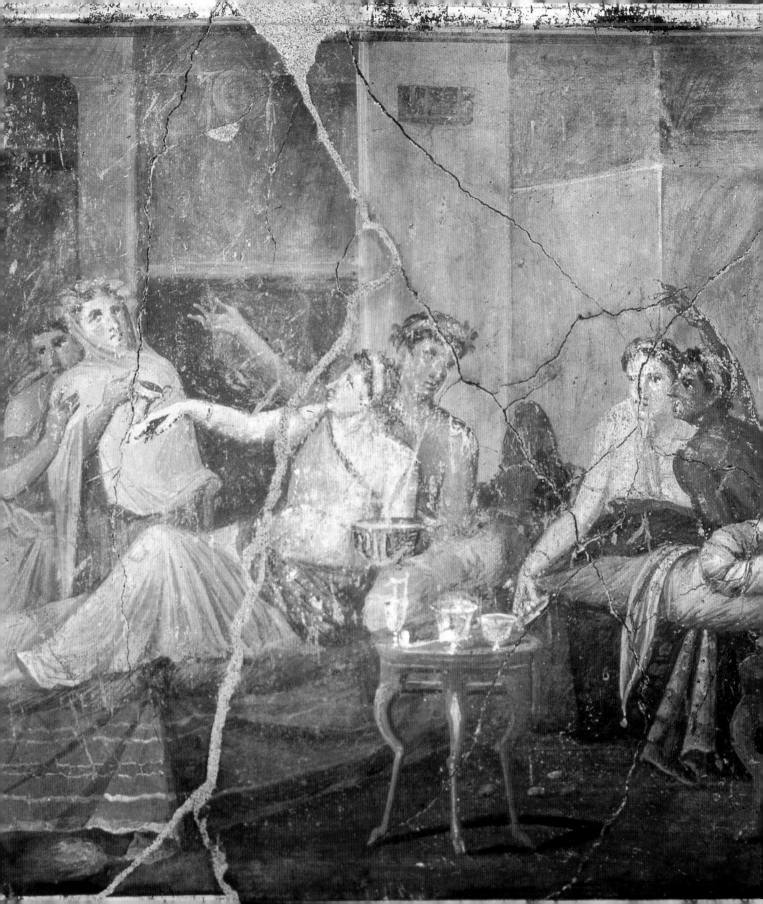

PUBLIC DISPLAYS

Without denying the erotic potential of the public baths, where mixed bathing had become widespread, we still maintain that to identify effectively incidents of transgression and authentic erotic desire, as can be perceived at Pompeii, we should look for less obvious clues that will better reveal the mentality of the age.

EROTICISM AT THE BANQUET

A moment in which the erotic urge in the Roman world can best be seen is doubtless that of the banquet.

It was customary in Roman life to consider the evening meal not only the most important of the day from a nutritional point of view but also one of the most interesting occasions for socializing with family or friends, as well as an extended circle, often offering occasions of not improbable sexual implications. A convivial gathering, therefore, in addition to being an occasion to celebrate for its own sake for many wealthy people—and often also an occasion for many people who were not wealthy to eat decently at a real table—was also a chance to let go, to abandon oneself to new sexual approaches or simply to attempt to do so.

We know much from the sources about what occurred in Rome, but less about what happened in Pompeii. There, however, a substantial body of evidence provides very precise information that can help us understand the extent and importance of banqueting in day-to-day interpersonal relationships.

The grandeur of the banquet at times made it a true celebration. The biggest and most

37. Fresco with banquet scene.
End of the Third Style. ca. A.D. 35–45. Pompeii, House of the Chaste
Lovers (IX.12.6), *triclinium*, west wall.

highly prized fish attained amazing prices on the market (see, for example, Martial X.31), completely out of proportion with similar fish of normal size, simply because they permitted the buyer to tell his guests that the pleasure of eating the best that Rome had to offer that day was reserved only for them. Lucullus spent figures comparable to the annual salary of a high functionary of the imperial bureaucracy for his own daily banquets. Horace leaves us a witty description of a sumptuous banquet in the last of his *Satires* (II.8), while in another (II.4) he is positively lavish with the highly refined precepts of a *grand gourmet* regarding the choice and preparation of the foods. Whatever involved the exhibition of oneself during these banquets is recounted magisterially by the caustic pen of Petronius in his description of the dinner at which the protagonists of his *Satyricon* find themselves after having invited themselves to the house of Trimalchio, the fabulously wealthy parvenu who has become one of the immortal figures of literature.

Pompeii, on the other hand, speaks not only with words but also through tangible archaeological remains. The importance that the society of a peripheral city placed on banqueting is documented for us by the *triclinia* of the lavish houses of princely dimensions—such as that of the House of Menander, more than 80 square meters—and by the stoves and ovens in the kitchens of the great households, such as those in the Villa of the Mysteries, both conceived expressly to provide hospitality to a large number of persons. In the *triclinium* of the House of the Vettii, the frieze depicting cupids engaged in various activities, which take up a space on the wall probably proportional to the income the activities brought to the owners, seem to want to tell the guests about the numerous sources of income that the brothers Vettii enjoyed. We are, of course, reminded of what occurred at Trimalchio's banquet, when one of his staff read out *coram populo* the list of the riches that had flowed into his treasury just in the last few days.

And yet in many Pompeian homes, especially in all those house-shops, the kitchen is completely missing, probably replaced by a simple portable burner. It is easy to infer how a significant portion of the population would always be hunting up dinner invitations (cf. Horace,

Satires II.7, 29–35), a custom not disdained, by the way, by the poets, especially Martial (II.18; II.79; III.60; IX.19; IX.100; X.19). This is confirmed by a graffito found inside the Basilica, which most likely expresses grievances against the owner of the Villa of the Mysteries himself: "O Lucius Istacidius, rude fellow that he is, who doesn't invite me to dinner" (*CIL* IV 1880). Another graffito reads: "Health to whoever invites me to lunch" (*CIL* IV 1937).

It should be noted, however, that the decorative elements of the *triclinia*, or even the decorations sometimes present on built-in *triclinia* and pallets, prefer to ignore any reference to the erotic or lewd component present in the banquets, or filter it through irony and parody, which now appear increasingly clearly as convincing keys to the exegesis of many paintings in Pompeian houses.

The banquet room of a recently excavated productive complex at Pompeii, a bakery, probably used for restaurant or banquet service, displays a decorative scheme that exemplifies the subject. On the side panels of the median zone of the walls, winged good-luck figures bear spring vegetables, game, delicacies and other symbols of the abundance of the table, while the pictures in the central panels treat the Hellenistic theme of the banquet with *hetaeras* (courtesans) in a manner that is at least jocose if not joyous.

The little scenes, set in different seasons of the year—indoors, outdoors and under a portico—illustrate couples serenely reclining at a banquet, intensely enjoying the pleasures of wine as well as those of love, at times amid a swarm of slaves, attendants and musicians. The erotic characterization of the context is nevertheless only a pretext that the painter uses to sketch a particular "comic" event taking place.

In one picture (Fig. 37), we see a woman who has risen from the convivial couch—the man is already in the arms of Morpheus—and put on her cloak, but before leaving she wants to drink a farewell cup to the health of the two other couples present, who are still sober. Unfortunately, lifting the cup is fatal to her precarious stability, and the slave boy, whose facial expression tells us he is used to such duties, must come to the rescue and support her from behind to keep her from falling over.

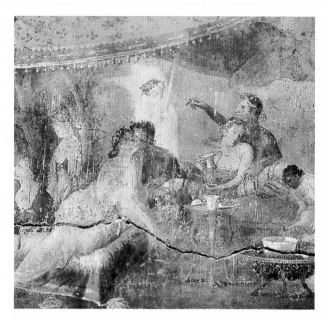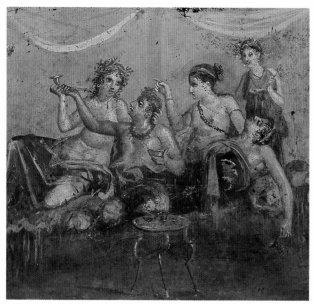

In the second picture (Fig. 38), the so-called "Chaste Lovers" for which the complex is named, a couple, sheltered by an awning from the scorching rays of the summer sun and intent upon a highly sensual, though still chaste, kiss, is surprised by the man's father, who, armed with a cane, hastens to give a sound lesson to his son caught squandering his money on loose women.

In the third and last scene (Fig. 39), a drinking contest between two men, cheered on by their respective female companions, ends with the sudden, but not unexpected, collapse of one of them. A maid tries in vain to revive him with a *flabellum* (fan)—while his lady friend persists in inciting him by pointing out the resistance of his opponent, whose greater capacities she herself admires.

Clearly such spicy little scenes have the job of giving a merry band of dinner guests a dose of glee to kick off a jovial evening. They may provide ideas for repartee or suggestive remarks that compare the situations depicted to real ones in which some of those present might have been involved. But it is also clear that reference to erotic situations in close connection

38. Fresco with banquet scene, known as the "Chaste Lovers."
End of the Third Style. ca. A.D. 35–45. Pompeii, House of the Chaste Lovers (IX.12.6), *triclinium*, north wall.

39. Fresco with banquet scene.
Fourth Style. Probably A.D. 62–79. Pompeii, House of the Chaste Lovers (IX.12.6), *triclinium*, east wall.

with banqueting, although viewed here from an ironic point of view, indicates eroticism in connection with the convivial reunion.

More explicit than other similar scenes, because it is not removed from the context, is the picture that adorned the peristyle of the House of the Physician (VIII.5.24) (Fig. 24), in which people recline at a banquet on the *triclinium* couches and watch the erotic performance of a pygmy couple.

As already noted, here too the intent is humorous or, more properly, satiric, since the pygmies, beings perceived as deformed and therefore worthy of derision, are the protagonists of the erotic circus. The scene is highly indicative of how real performances took place at banquets against a sexual backdrop, if not full-fledged couplings, which must have served to stimulate the libido of the participants, or even lead to orgies. It is known that in Rome completely nude girls sometimes served at banquets (Suetonius, *Life of Tiberius* 42.2), and in various places precious objects of table decoration have been found with clearly suggestive or even quite blatant erotic depictions that leave no doubt as to the link the ancients saw between sexual pleasures and the pleasures of the table. Even more, they indicate how the convivial

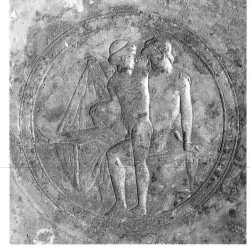

40. Fresco depicting couple making love outdoors beneath a canopy.
In the center of the scene, in the foreground, the principal figure is a female flute player. She accompanies the lovers' movements with her music; on the right another woman plays a rattle to provide the rhythm. Behind the couple a servant bears an amphora with wine, and on the left another servant draws water from a spring to mix with the wine. On the right a passerby leaning on a tree appears to be watching the scene with interest.

Fourth Style. ca. A.D. 45–79. Pompeii, right face of the masonry summer *triclinium* in the House of the Ephebe (I.7.11).

41. Detail of bottom of a bronze pot with a satyr and nymph making love.
From Pompeii. First century B.C. to first century A.D. Naples, Museo Archeologico Nazionale, inv. no. 27671.

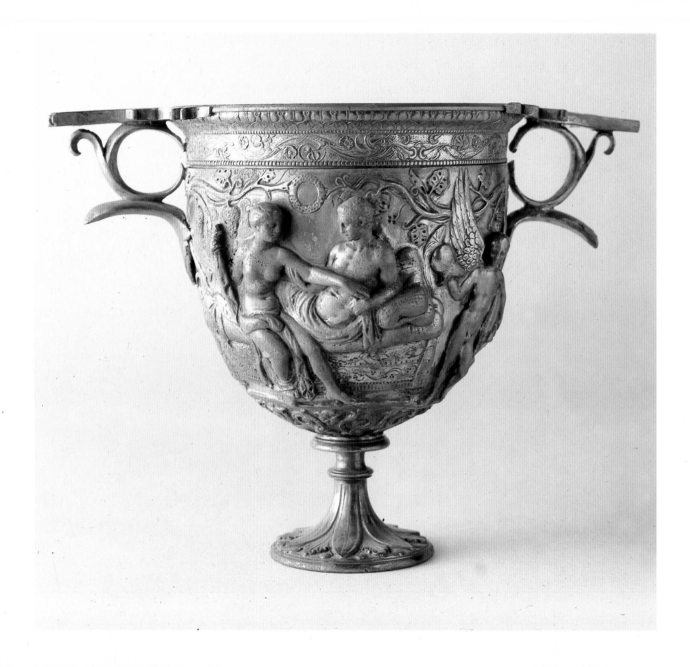

42. Silver cup with embossed scene of Mars and Venus observed by Cupid.
From Pompeii, from the silver treasure of the House of Menander (I.10.4). Augustan. Naples, Museo Archeologico Nazionale, inv. no. 145515.

43. Drawing of a terracotta Priapic flask (so-called *drilopotes*).
The liquid, poured in through an opening behind the figure's head, was sucked through the tube of the phallus. Juvenal (II.95) and Pliny the Elder (*NH* 33.1) refer to the practice.
From Herculaneum. Augustan (from Barré, *Musée Secret*, pl. 57). Naples, Museo Archeologico Nazionale, inv. no. 27858.

moment could be understood as a prelude to sexual activity in which it was necessary to give the right weight to erotic arousal (Figs. 40–41). In fact, it would also be interesting to investigate—if only it was possible—the importance of music in such a context to kindle erotic desire, since musicians appear not infrequently in paintings with banquet scenes, and especially in those with clear references to amorous activity (Figs. 38, 42). In other contexts, with reference to the pleasure of the senses, the figure of Erato, muse of erotic poetry appears. In one of the main *cubicula* of the House of Caecilius Jucundus, she appears with the attributes of the lyre and plectrum in the

picture on a side wall, while the other contains Bacchus, god of wine. Both figures seem to serve as a fitting conceptual accompaniment to the love of Mars and Venus, shown in the picture on the central wall.

Let us return to table decoration. On two silver *kantharoi*, among the most beautiful pieces from the House of Menander, love is again projected into the muffled and transfigured dimension of myth. Mars and Venus, with Eros looking on, are protagonists of the embossed erotic scenes (Fig. 43). On the so-called Warren cup (Fig. 44), men and youths are portrayed explicitly engaging in sodomy. The use of erotic stimuli was widespread also among those who could not afford silver cups. Scenes of the carnal pleasures consummated in various positions appear especially on

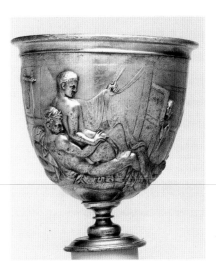

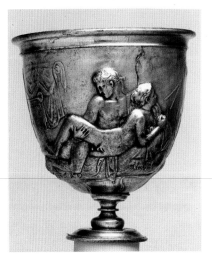

44a. Warren cup, side A.
Depiction of intercourse between two men in the disquieting presence of a slave boy peeking from behind a slightly open door.
Provenance not stated. Augustan. London, British Museum, GR 1999.4-26.1.

44b. Warren cup, side B.
Depiction of a man and a youth having intercourse.
Provenance not stated. Augustan. London, British Museum, GR 1999.4-26.1.

medallions for appliqué on the more affordable *terra sigillata*, found chiefly in the Rhône valley. Yet on Arretine ware—the fine china in well-to-do households—explicit depictions of lovemaking are also more than occasional (Fig. 45).

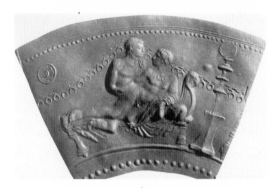

The House of the Moralist, in Via dell'Abbondanza, provides a precise clue to how banquets at Pompeii as well as Rome proved to be an outstanding occasion to tarnish the virtue of the *matronae*. In the room used exclusively for banquets, where masonry *triclinium* couches eloquently attest to the proprietor's inclination to entertain, the willing host had verses painted right on the walls dictating precepts to his guests so that the convivial rite would proceed in the most seemly harmony without degeneration.

One maxim in particular (*CIL* IV 7698b) says: *Lascivos voltus et blandos aufer ocellos coniuge ab alterius, sit tibi in ore pudor* ("Avoid giving killer looks to the wives of others with desirous expressions; harbor modesty in your mouth"). This maxim, together with two others, exhorting cleanliness, personal decorum and respect for the household objects, in addition to desisting from arguments that could lower the tone of the conversation (cf. Martial II.72), was intended to eliminate anything that might mar the serenity and pleasure of an evening in company. It remains, however, symptomatic of how frequently such circumstances must have been present and how many "killer looks" must in fact have been launched in search of possible prey.

Despite the warning, some rake tried anyway, or so a graffito found on the west wall of the garden of the same house seems to tell us—if it is indeed a warning from someone who had good reason to regret the "attentions" paid to a lady. *Aser, ab amona[e] loco*, says the inscription (*CIL* IV 8870), which in classical Latin would sound like *Anser, abi amoenae loco*—roughly, "Beat it, Duck, keep away from my girlfriend." Seduction, then, principal element of erotic tension, was not above frequenting the "salons" of Pompeii.

45. Detail of Arretine pottery cup with scene of two men making love. Augustan.

LASCIVOS VOLTUS ET BLANDOS AUFER OCELLOS CONIUGE AB ALTERIUS, SIT TIBI IN ORE PUDOR

AVOID GIVING KILLER LOOKS TO THE WIVES OF OTHERS WITH DESIROUS EXPRESSIONS; HARBOR MODESTY IN YOUR MOUTH.

CIL IV 7698b

EROTIC PERFORMANCES

Alongside amorous shows designed to arouse the senses in a classical discussion of roles, in which seduction becomes a subtle game, even more intriguing than the actual satisfaction of the desire, there existed more ardent manifestations of eroticism. Some must even have been coarse and vulgar, intended for consumption in a definitely less refined sphere, even in public, where the element of transgression was the uninhibited display of desire in the presence of anybody and everybody, not just in a restricted circle of friends or acquaintances in a context that could still be considered "private."

The favorite place for such moments of lustful eroticism was the theater. In addition to the usual repertory of comedies and tragedies, it was more common to attend scurrilous mimes, Atellan farces and *fescennini*, a genre in which sexual allusions played a substantial and conspicuous part. Sexual acts were often mimed on stage, and sometimes the players forged ahead and completed the act.

Clearly in such contexts excitement swept the crowd, and in the seats situations tending toward degeneration could occur. Augustus, in his moralizing anxiety, sought to contain this phenomenon by having the women sit in a separate section of the theater, lest the ardor on stage spill over into the audience, endangering their virtue (the subject of frequent complaints), or at the least to keep their involvement from becoming a show within the show.

It is probably exactly in deference to such a disposition that, in the Augustan age, M. Holconius Rufus and his brother Celer, in the course of a restoration of the theater they financed, built the *summa cavea*, the upper drum of seats, resting on a covered corridor, to allow women to attend the shows, befittingly separate from the men. It would be superfluous to mention here the citations of the ancient authors regarding the crudeness of the scenes performed at the theater. It is more interesting to observe the memory preserved at Pompeii of these players, actors and mimes.

These actors are mentioned in numerous graffiti. Sometimes the players themselves left their record—thus we have such names as Petroselinus, Capito, Scepsimus, Vatifonis, Occasus, Autostolus, Cerebrimotus, Cellicus, Cicer, Habitus, Dianesis (*CIL* IV 5400, 10243, 10246; *CronPomp* V 1979, pp. 75–77), as well as those of the characters of the Atellan farce, Pappus, Maccus, Buccus and Dossenus, of the "masque," or of the particular human character they play. Sometimes it is their fans who, in preserving their memory, also show the wide following they enjoyed among the broadest strata of the population (cf. *CIL* IV 3866f., 3877, 5233, 5395, 5399, 5404, 7919).

It is interesting for us to note the considerable success that a mime of Noceria, Novellia Primigenia, attained at Pompeii as well as the other cities of Campania. As an itinerant showgirl whose tours covered a wide area she no doubt enjoyed a popularity earned not only from her talents on the stage.

This singular figure, halfway between a Belle Époque chanteuse and a "high-class" lady of easy virtue, must have used her charm and sensuality, which could probably be enjoyed not only on the stage, to enchant the senses of more than one Pompeian. It is certain that at Pompeii this fascinating girl's address made the rounds (*CIL* IV 8356): "In Nuceria, near Porta Romana, in the district of Venus, ask for Novella Primigenia." To her an anonymous Pompeian directs an elegiac distich full of poignant sensuality (*CIL* IV 10241): *Primigeniae Nucer(inae) sal(utem). Vellem essem gemma ora non amplius una ut tibi signanti oscula pressa darem* ("Health to Primigenia of Nuceria! For just one hour I'd like to be the stone of this ring, to give to you who moisten it with your mouth, the kisses I have impressed on it."). Still other Pompeians record her name repeatedly (*CIL* IV 10244; unpublished inscription from house IX.12.9). Novellia's allure made more than one heart palpitate, and it is easy to imagine the cheering of the men in the crowd when she performed.

PRIMIGENIAE / NUCER(INAE) SAL(UTEM)./VELLEM ESSEM GEMMA ORA NON AMPLIUS UNA / UT TIBI SIGNANTI OSCULA PRESSA DAREM

HEALTH TO PRIMIGENIA OF NUCERIA!
FOR JUST ONE HOUR I'D LIKE TO BE THE STONE
OF THIS RING, TO GIVE TO YOU WHO MOISTEN
IT WITH YOUR MOUTH, THE KISSES
I HAVE IMPRESSED ON IT. *CIL* IV 10241

The performances of acrobats, contortionists, jugglers, tightrope walkers, either in the streets or in establishments similar to nightclubs, also could have a marked erotic bent. A picture from Pompeii found in a *caupona* along the Via di Mercurio, now no longer preserved but known from a drawing made in the early nineteenth century, illustrates the erotic prowess of a couple of such artists, who manage to consummate the sexual act in an utterly improbable position, while balancing on a tightrope and without causing the woman to spill a drop of the wine from the glass in her hand (Fig. 46).

In cases of this sort it was very difficult to identify the true skill, but it is evident that live sexual acts, even completely atypical ones, were

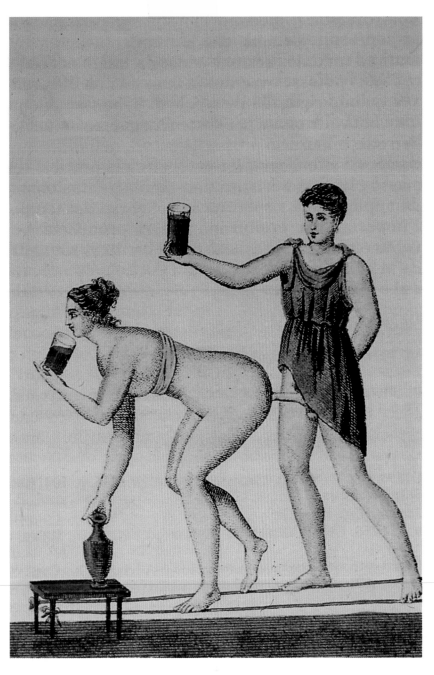

46. Reproduction of a painting, now lost, from the Pompeian *caupona* at VI.10.1 with depiction of erotic performances by acrobats.
From *Musée Royal de Naples*, pl. 35. First century A.D.

characteristic of such spectacles, which relied on the acts to spice up the show, counting more on the eroticism than on the talent.

Nor should we fail to mention the total dissoluteness of this sort of show, where all limits and restraints were artfully exceeded—if, as again Martial informs us, it was possible in the arena to see even women coupling with bulls, in emulation of the affair of Pasiphae (*Spectacula* 5).

Another type of highly erotic show was something like what we know as a striptease. It was performed, perhaps with sham improvization, by accommodating waitresses in dives, low wine shops or other premises in which the entertainment of the customers came to be of substantial importance. Along the Via dell'Abbondanza some girls with the exotic names of Aegle, Maria and Zmyrina are believed to have used their feminine arts to satisfy the particular needs of the customers in the *thermopolium* run by Asellina.

Along the Via Stabiana, an inscription (*CIL* IV 3951) gives us a fairly explicit idea of the sort of thing that must have occurred in the *thermopolium* at I.2.24: *Restutus (dicit): Restetuta pone tunica; rogo, redes pilosa co(nnum)* ("Restitutus says: Restituta come on, take off your dress and show us your cunt hair").

The graffito echoes the incitements to and comments by excited habitués of the place during the performances of strippers *ante litteram* who performed there, who remind us of Martial's salacious lines (*Apophor.* 203) in which he observes that the lascivious movements of a dancer from Gades (Cadiz) would drive any man to masturbation.

Let us not, however, forget the very strong erotic attraction exerted on women by other important players in the spectacles of the ancient world, the gladiators.

The fascination they held for the female spirit and the violent erotic attraction they aroused even among women of high station would require a careful psycho-sociological analysis as a social phenomenon. There would be no lack, for our own age, of interesting comparisons with other categories of persons, but we would stray from our subject. Of course, not even the ancient authors themselves could explain why the gladiators enjoyed so much

success with the women; they limited themselves to recording exactly how the excitement that was provoked pertained to the figure, rather than describing the physical qualities of the person. Juvenal dedicates many lines of his *Satire* against women (6.82–113) to tell us of the many adventures faced by Eppia, a senator's wife, for love of a gladiator, Sergiolus (little Sergius), whose name alone suggests the inadequacy of his appearance, ravaged, as it was, by wounds and scars. Juvenal's explanation for her insane passion is symptomatic (6.110, 112): *Sed gladiator erat: facit hoc illos Hyacinthos.... Ferrum est quod amant.* ("But he was a *gladiator*. That made him look as beautiful as Apollo's friend Hyacinth.... It's the sword they're in love with"). Nor is evidence lacking at Pompeii of the favor that the women granted to the gladiators. We are obliged to conclude, to explain the phenomenon, that women watched the gladiatorial shows in a state of exquisite erotic arousal.

The evidence comes first from the gladiators themselves, but it does not seem to be empty boasting. The Thracian Celadus, thus, is called the "heartthrob of the girls" (*CIL* IV 4397) or "pride of the girls" (*CIL* IV 4345), while the *retiarius* Crescens boasts that he is "lord of the girls" (*CIL* IV 4356) and even "doctor of the night dolls, morning dolls and of the other dolls" (*CIL* IV 4353).

Sometimes, however, even outsiders, malicious though they may be, do not fail to note come-hither glances and to suspect interest in the gladiators on the part of ladies of the Pompeian aristocracy. Thus it happens that the wife of a magistrate, well known for the lavish gladiatorial shows he loved to offer the citizens, can lay herself open to gossip, while she is seen in place of her husband buying two brawny gladiators. An inscription surreptitiously records the fact (*CIL* IV 8590): "To the wife of Decimus Lucretius Valens has been sold Onustus, prime rider; Sagatus, prime-quality Thracian *mirmillo* has been sold."

Decidedly, the gladiator, with his disregard for danger, with the impetuosity spent freely in combat, with his inherent ferocity, sent off erotic signals that threw women into raptures, charming them irresistibly.

SED GLADIATOR ERAT: FACIT HOC ILLOS HYACINTHOS.
... FERRUM EST QUOD AMANT

BUT HE WAS A GLADIATOR. THAT MADE HIM LOOK AS BEAUTIFUL AS APOLLO'S FRIEND HYACINTH.... IT'S THE SWORD THEY'RE IN LOVE WITH.
JUVENAL, *SATIRES* 6.110–112

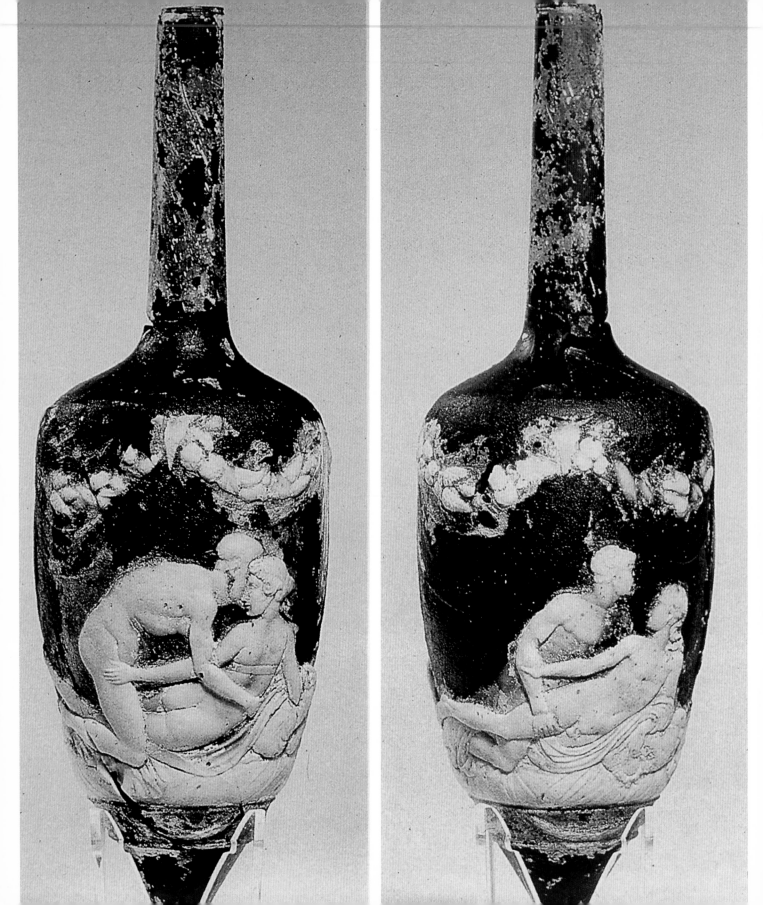

MANIFESTATIONS IN THE PRIVATE SPHERE

In addition to the erotic practices in a more or less public sphere, such as the occasions examined above, there was no lack of substantial appearances of it in a more private ambit, as the evidence will soon make clear.

EROTIC AROUSAL FROM READING

First of all, one became aroused by reading. Martial leaves no room for doubt. Sometimes he is being ironic, as in III.68, where he dismisses the proper matrons from further reading of his book, warning them that from that point on he would treat scabrous topics, no longer suitable for them, then concluding (11 f.):

> If I know you well, you were already tired by the length of the book,
> but now you read it with interest to the end.

At a certain hour of the evening, moreover, it is permitted for even the Catos to let themselves go (Martial X.20, 21), nor, after all, are all his epigrams to be read at night (Martial XI.17). At other times such evidence becomes decidedly brutal, but, for that very reason, absolutely indicative beyond all metaphor of the libidinous arousal that was sought in reading by both men and women (Martial XI.16, 5 ff.):

> O how many times will you hammer your tunic with the swelling of your member,
> though you be more well-mannered than Curius or Fabricius.
> And you, too, my girl, will read the games and indecency in this
> book of mine, wet between the legs even if you are from Padua.

47. **Cameo-glass perfume flask with scene of intercourse between a man and a woman, on side A, and between a man and a boy, on side B.**
From Ostippo (Estepa, near Seville). Augustan. George Ortiz collection.

Blushing Lucretia has set down my book,
because Brutus was there. Now he's gone, and, there, she's reading it again.

Insistent in this regard, our Martial, who supplies precious information on the smutty texts circulating at the time by various authors and, especially, on the crudely erotic use that was made of them (XII.95):

Go ahead and read, Instantius Rufus, the revealing books of Mussetius
that compete with those written in Sybaris,
and the texts dipped in keen itching.
But do it with your girl, so that it does not come to pass
that you sing the wedding hymn with lustful hands,
playing the husband without a wife.

He even manages to figure these texts for us almost visually in an epigram that is particularly significant for our topic (XII.43):

You recited verses to me, Sabellus,
all too well-finished, on how to take pleasure
that not even the women of the brothels know
nor the satirical pamphlets of Elephantis.
There are in them new love poses,
to bewilder the hardened depraved man,
such as male prostitutes provide, and keep quiet about:
like how five can join in intercourse
and how even more can link into a chain.
Things to do only with the lights extinguished.
To be such a polished poet for these things!

THE USE OF IMAGES TO AROUSE

We have not been able, of course, to find the evidence for it at Pompeii, but, in compensation, images inspired by such works, illustrating a variety of sexual positions (Figs. 48–60), have been found in the pictures, sculptures and everyday objects in more than one house as well as in the brothel. The context, in these cases, suggests that such *schemata* or *figurae Veneris*, even in a decorative element with a subject, in this case, of erotic bent, and in the clear desire to imitate fashions that were the prerogative of the upper classes, had an actual function as instruments of sexual arousal. This leads us to yet another field of eroticism, visual stimulants.

In this context, it is particularly interesting to note that explicit erotic depictions are found copied on such typically feminine objects as silver mirrors and precious perfume bottles (Fig. 47). It is evident that the scene, which the woman could study at her toilette, not only oriented her action, but prepared her, in the subtle thrill of waiting, for the amorous encounter for which she was beautifying herself. Today we need not care whether such a vision corresponds to a "male chauvinist" credo or was a choice appreciated (hence not merely submitted to) by the woman herself, as the different vision of the Roman woman that has been emerging in recent years might suggest. It is significant here to note how the Roman world made use of the evocative power of images also for professedly erotic aims, even making visual solicitation a cardinal moment of sexual arousal.

This is what Suetonius was talking

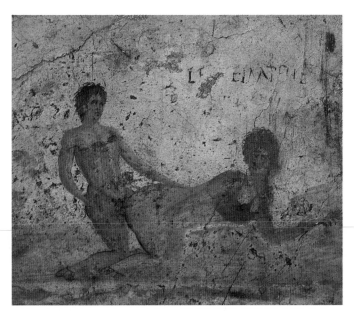

48. **Scene of coitus with the words** *Lente impelle* (*CIL* **IV 794**).
From Pompeii, House of the King of Prussia (VII.9.33). ca. A.D. 69–79.
Naples, Museo Archeologico Nazionale, inv. no. 27690.

about when he says (*Tiberius* 43.2) that in his isolation on Capri the emperor Tiberius "adorned his bedrooms with paintings [*tabellis*] and statuettes derived from the most obscene paintings and sculptures, as well as the books of Elephantis, so that no one [of the girls and homosexuals recruited at his pleasure] should be without a model for the position ordered."

It is clear in what way these pictures, while useful to Tiberius's lovers for detailed technical information on what was required of them, were even more useful to Tiberius to stimulate his imagination about this or that particular position, which he then suggested to his lover of the moment.

This function as model may certainly also be invoked for places like the brothel, where the depiction of varied positions can have effectively constituted a reference for the customers, more specific than their merely thematic sense, aiming to elevate a perfectly ordinary moment of basely mercenary sex in a cushioned atmosphere of aristocratic pleasure. It cannot, however, be the purpose of the sex scenes found in the bedrooms of ordinary Pompeian houses. These clearly imitate refined fashions, a suggestive function that tends to corroborate the erotic atmosphere for the amorous rites for which the room was destined.

Once again Suetonius on Tiberius (44.2) comes to our aid. The emperor, he tells us, inherited a painting by Parrhasius showing Atalanta performing oral sex on Meleager, but

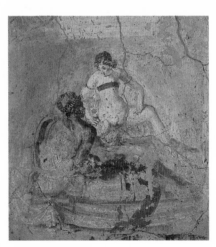

under the terms of the legacy, if he considered the subject unsuitable, he might choose the sum of one million sesterces. He not only preferred to keep the picture, but placed it right in his bedroom.

Suetonius uses the anecdote to illustrate the erotic

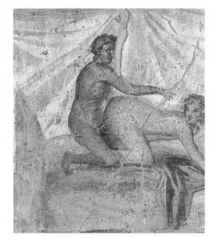

49. Scene of *mulier equitans*.
From Pompeii. First century A.D. Naples, Museo Archeologico Nazionale, inv. no. 27686.

50. Painting with scene of intercourse behind a curtain.
From Pompeii. First century A.D. Naples, Museo Archeologico Nazionale, inv. no. 27696.

manias of Tiberius, so we should not be surprised to learn that a person as exceedingly wealthy as Tiberius could have preferred a work of art by a famous Greek artist, more than four hundred years old, to even so large a sum. What is indicative for us is that Suetonius takes pains to point out that the painting was placed in the bedroom, as an aid to pleasure. He clearly intended to make us understand how the emperor, to gratify his libido, not his aesthetic sense, was willing to sacrifice any figure. However, this passage is clear evidence of the function that such erotic pictures fulfilled in the bedroom. And what is more, a remark of Ovid (*Tristia* II. 524) suggests that even the apartment of the sober-minded Augustus contained a painting depicting various types of sexual congress in an array of different positions.

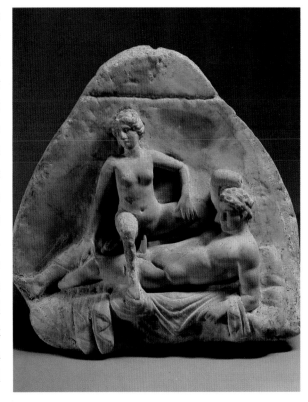

If the works of art served to characterize the function of the room, they also tended to stimulate the lustful desires of the person who lived in an environment considered optimal. The paintings—or sometimes mosaics or sculptures—lured and readied the spirit for the delights of passion.

Propertius confirms for us that this was already well known by the Romans themselves, when, in a moment of cloying didactic moralism, he inveighs—as Tibullus elsewhere had done against the inventor of weapons—against the man who first painted obscene pictures, which, now to be found in houses everywhere, "corrupt the naïve little eyes of the girls, inciting them to depravation" (*Elegies* II.6, 29 f.).

51. Bas-relief with scene of *Venus pendula*.
From Pompeii, *triclinium* of the *caupona* at VII.7.18. First century A.D. Naples, Museo Archeologico Nazionale, inv. no. 27714.

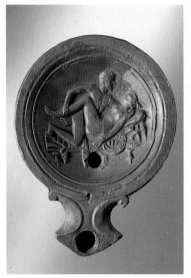

We can now add to the already considerable body of evidence for Pompeii in this regard a luxurious house still being excavated in *Regio* IX, *insula* 12, with secondary entrance at no. 9 and main entrance not yet brought to light. Its residential and reception quarters open onto the northern and eastern walkways of a triple portico that borders a manicured garden. In the *triclinium* are painted a variety of game and in the lunettes are a basket of fresh fish just plucked from the sea and, on the other side, a lobster and a moray eel, clear emblems of the delicacies offered by nature at the table. They not only describe the function of the room but also tempt the palate to the enjoyment of the pleasures of the table.

Similarly, on the rear wall of the master bedroom, which communicates directly with the living room and is preceded by an anteroom as a sort of boudoir, a central panel shows Venus fishing, a common allusion to the majesty and divine

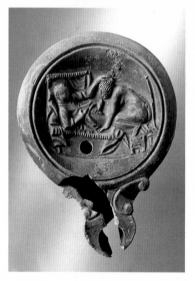

protection of the world of love. On a side wall, a satyr groping a maenad from behind (Fig. 61) brings love down to earth, even if it is still in the mythic realm. Love becomes absolutely real on the other wall, with a carnal encounter, albeit badly faded and no longer easy to see. However, we can make out on the left a woman lying on the bed, her legs raised and spread, being penetrated by a man standing on the right.

The archaeological findings leave no doubt that this was the master bedroom, with two beds, used by the couple who owned the house. The erotic scenes would not have served as models but rather were intended to highlight with subtle erotic allusion the room's role as love nest.

52. Terracotta oil lamp with sex scene in relief on the disk.
From Pompeii. First century A.D. Naples, Museo Archeologico Nazionale, inv. no. 27865.

53. Terracotta oil lamp with scene of fellatio in relief on the disk.
From Vesuvius area. First century A.D. Naples, Museo Archeologico Nazionale, inv. no. 27864.

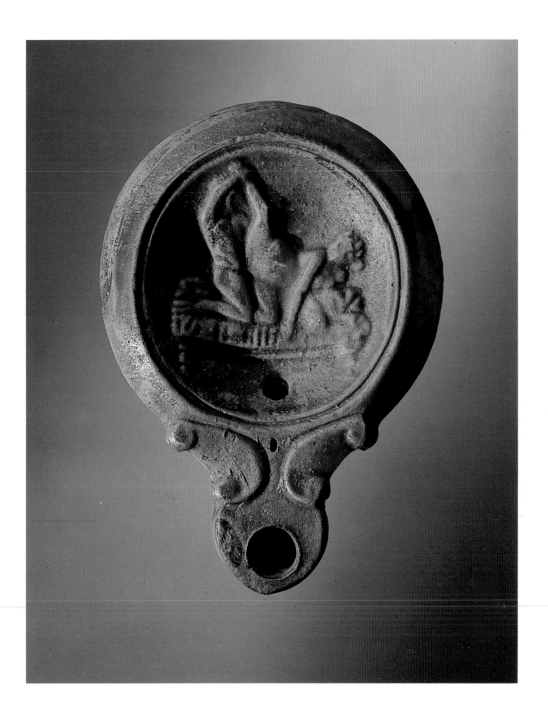

54. Terracotta oil lamp with scene of erotic acrobatics in relief on the disk.
From Herculaneum. First century A.D. Naples, Museo Archeologico Nazionale, inv. no. 27862.

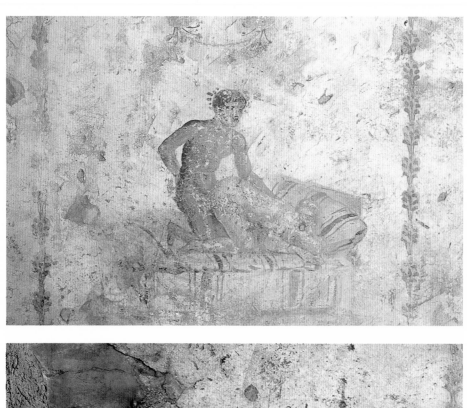

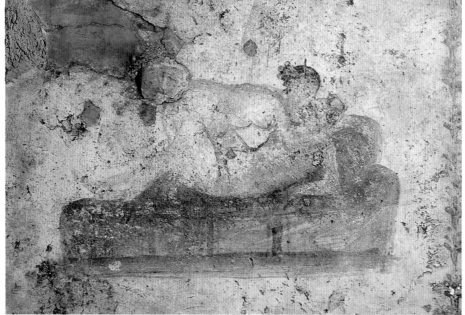

55. Painting with sex scene.
Fourth Style. A.D. 62–79. Pompeii, north wall of *cubiculum f* of the
House of the Restaurant (IX.5.14/16), west section.

56. Painting with sex scene.
Fourth Style. A.D. 62–79. Pompeii, south wall of *cubiculum f* of the
House of the Restaurant (IX.5.14/16), west section.

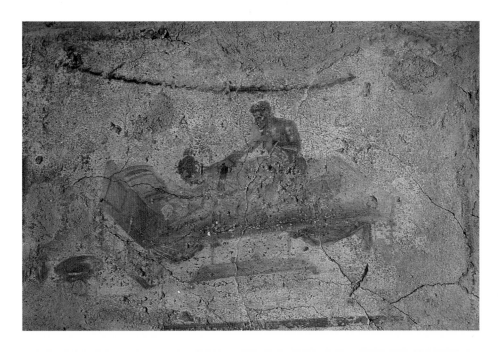

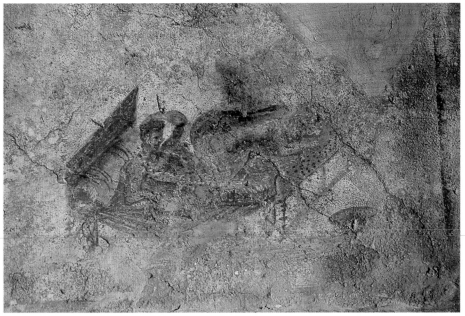

57. Sex scene.
Probably A.D. 72–79. Pompeii, south wall of the brothel (VII.12.18),
west section.

58. Scene of lovemaking.
Probably A.D. 72–79. Pompeii, west wall of the brothel (VII.12.18),
north section.

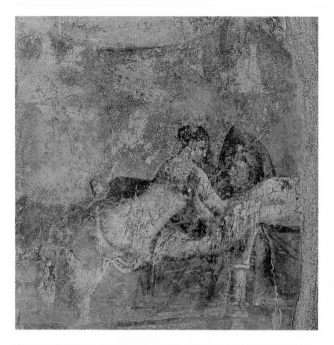

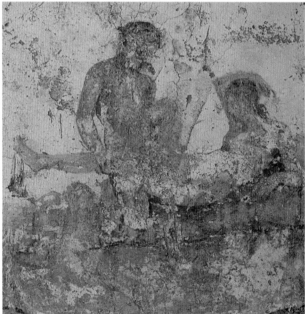

59. In this painted scene, the man, on the bed draws a half-clothed woman to him.
Final Third Style. ca. A.D. 35–45. Pompeii, south wall of the *cubiculum* (11) of the House of the Beautiful Impluvium (I.9.1).

60. Sex scene.
Note the right arm of the woman bent behind her head in a gesture that in this type of picture is usually used for men and conventionally indicates availability and inclination to receive sexual pleasure. The gesture makes the woman the protagonist of the scene.
Fourth Style. A.D. 62–79. Pompeii, west wall of *cubiculum f* of the House of the Restaurant (IX.5.14/16).

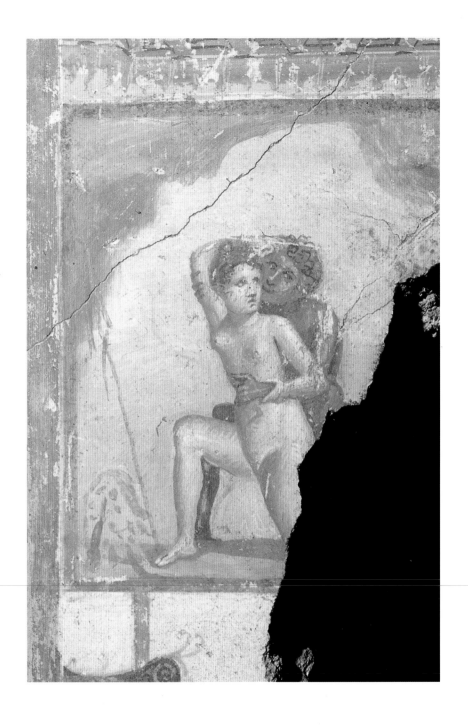

61. Painting of a satyr groping a maenad from behind.
Fourth Style. ca. A.D. 45–79. Pompeii, west wall of the master
bedroom of the house at IX.12.9 (*posticum*).

EROTIC PICTURES WITH DOORS

Another Pompeian house, where some interesting discoveries are not without surprises, takes us to an even more risqué and possibly even more complicated conception of eroticism.

The House of the Centenary is one of the most prestigious noble *domi*, or houses, in the city, situated along the upper *decumanus*, the Via di Nola. In a private part of the house, created from the servants' wing, but doubtless used by the owner to meet friends (as evidenced by a large dining room with exquisite wall paintings), there is a very large *cubiculum*, preceded by an unusually spacious anteroom. On the back wall of the *cubiculum*, a scene from mythology features Herakles, the hero representing strength and boldness, nude. On the two side walls, two scenes of a man and a woman having intercourse illustrate two different positions (Figs. 62–63).

The situation is thus quite similar to that found in the aforementioned house located at IX.12, or in the other similar Pompeian rooms. But the chamber in the House of the Centenary contains something different and absolutely unique in the archaeological record that has come down to us. Next to the front door, a peculiar window goes through the wall from one side to the other, creating another little

62. Detail of wall with scene of couple engaged in erotic games in a room with a picture with doors on one wall.
Fourth Style. A.D. 62–79. Pompeii, south wall of the double-alcoved *cubiculum* (43) of the House of the Centenary (IX.8.6).

63. Painting of couple engaged in erotic games in a room with a picture with doors on one wall.
Fourth Style. A.D. 62–79. Pompeii, north wall of the double-alcoved *cubiculum* (43) of the House of the Centenary (IX.8.6).

room communicating between the room and the anteroom (Fig. 64). The opening is slightly narrower toward the inside, 33 x 35.5 cm on the anteroom side, narrowing to 26 x 35 cm in the room. The base of the opening is 166.5 cm from the floor. Considering the small average stature of the people then, this height rules out that it was intended for looking from one room into the other or to pass objects, such as food. It is equally unlikely that it was a source of light, because the window was positioned for the purpose of capturing available light in the anteroom. Unfortunately, as Mau complains (*Bollettino dell'Istituto* 1881, p. 229), the nineteenth-century restoration did not take account of it, and indeed it is no longer visible. Our opening, however, would not have been in line with the window of the room next door, and we know that in Pompeian houses, where it was necessary to catch the light and pass it from one

room to another, the best location and angle for the light sources are always sought out and favored.

Something else to note archaeologically is that inside the passage a circular hole goes right through the ceiling. It is difficult to attribute a function to it, except to imagine that it held a wooden pole to lighten the masonry structure at that point. But it is more interesting to observe, on the right-hand side and near the *cubiculum* wall, two smaller holes, left by nails that served to hinge a wooden door with which the opening could be closed.

What purpose it served has not yet been made clear. The answer to the riddle may, however, be reached by

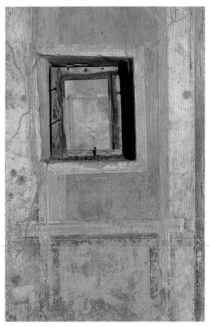

64a. 64b. Opening for *tabulae pictae* with erotic subject.
To the left of the entryway of the *cubiculum* the niche with communicating opening to the antechamber is clearly visible. In the niche, which was closed by a door, could be inserted from the antechamber *tabulae pictae* of erotic subjects.
First century A.D. Pompeii, west wall of the double-alcoved *cubiculum* (43) of the House of the Centenary (IX.8.6.).

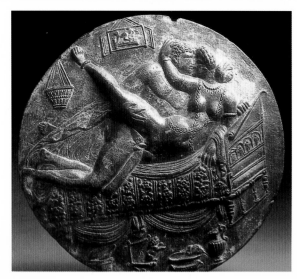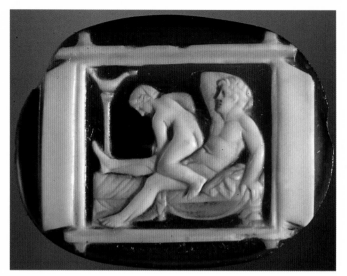

carefully analyzing the erotic paintings in the room. Behind all the amorous couples hangs a small picture showing two people disporting themselves in an equally erotic manner. The most interesting detail of the erotic picture within the erotic picture is the presence of two little wooden doors on either side of it, which could be closed to hide the picture from view.

It then becomes extremely interesting to note that the presence of a small erotic picture hung on the wall, one that could be hidden behind doors, is a common element in other portrayals of copulation, such as that on the bronze mirror in Rome in the Antiquarium Comunale (Fig. 65). A cameo in Naples in the Museo Archeologico Nazionale (Fig. 66) depicts one of these small pictures with doors, which, when open, permitted the viewer to admire fanciful approaches to the sexual act. Much is made in the scene of a lighted candelabrum next to the bed, a detail to which we will return. An erotic painting with doors, held up by a vegetal candelabrum, is also found in the *villa rustica* of Gragnano (Carmiano). Pictures with doors can also be seen on terracotta medallions found in the Rhône valley (Figs. 67–69).

Another detail not to be neglected is that the House of the Centenary contains six pictures that appear as inserts in a later phase of the wall decoration of the *triclinium* and

65. Bronze mirror with sex scene in relief; the room's furnishings are shown in detail.
On the wall is a picture with doors showing a couple engaging in a similar erotic game.
From the Palatine. A.D. 69–79. Rome, Antiquarium Comunale, inv. no. 13694.

66. Cameo depicting an erotic painting with doors.
Note the detail of the candelabrum next to the couple. First century B.C. to first century A.D. Naples, Museo Archeologico Nazionale, inv. no. 25847/15.

67. Medallion appliqué on terracotta vase.
A doored erotic picture of undetermined subject provides a background to the particular position being used by a couple.
From the Rhône valley. Second to third century A.D. (from Marcadé), Lyon, Museo.

the anteroom of the *cubiculum* mentioned above. That such a situation is not only the product of extemporaneous requirements of the nineteenth-century restoration, which encased the pictures in lead sheeting, is expressly confirmed by the excavation director, Antonio Sogliano (*Notizie degli Scavi di Antichità* 1879, pp. 149, 282), who assures us that in antiquity they had already been inserted in the previously decorated wall.

In other words, the owner of the house had bought pictures and had them inserted into the existing decoration directly on the wall. This phenomenon has been found

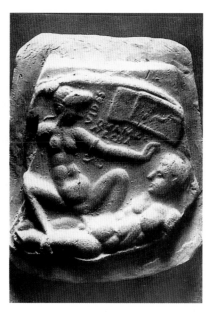

elsewhere in Pompeii in important houses, such as in the House of Menander, and usually involved *emblemata* in *opus vermiculatum* purchased on the art market and then inserted in the center of large mosaics prepared directly on the spot.

All this suggests to me the hypothesis that the opening we find in the *cubiculum* served to hold easel paintings, the famous *tabulae* often mentioned by the sources. These were made on a perishable material that has not survived. Such pictures, which the context leaves not the slightest doubt were of erotic content, were passed from the larger opening of the anteroom to be set into the masonry of the *cubiculum*, where the opening was narrower. Covered until the door was opened, the picture was revealed to suggest a particular sexual position. The

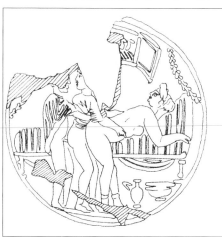

68. Medallion appliqué on terracotta vase with scene of ménage à trois.
On the wall is a picture with doors showing a pair of galloping horses. From the Rhône valley. Second to third century A.D. Lyon, Museum.

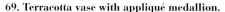

69. Terracotta vase with appliqué medallion.
Behind a woman mounting a man is a small painting with a door depicting a quadriga at the gallop. As in a comic strip, the woman says to the man, to increase his excitement: *Va(leas). Vides / quam be/ne cha/las* ("May you be well! See how well you open me"). From the Rhône valley. Second to third century A.D. Nîmes, Musée Archéologique.

possibility that the picture could easily be replaced from the adjacent room, perhaps by a slave, meant that each time the door was opened there appeared a new scene and position, in an erotic game of variety and surprise.

It is clear that if my hypothesis is near the mark we have here a room structurally conceived for the delights of love. Alongside the erotic pictures that belong to the room's permanent decoration, it was possible to enjoy other, interchangeable, ones, thanks to a specially designed and, for the day, sophisticated mechanism "of projection." I would not know whether to call this the conception of a refined mind, in relation to the tastes and the possibilities of the day, or a morbid one. But on second thought, if I am right, here we gain access to morbidly refined peaks of eroticism, which at this point no longer surprise us, even in an outlying setting such as Pompeii must have been.

At the edge of the House of the Centenary's manicured garden, a whole spacious room, a fountain-nymphaeum, was installed. It was surrounded by a cryptoporticus and inserted, pictorially, within a *paradeisos* (wild animal park). Residing within the imitative architecture of patrician villas, it included detached pavilions and gazebos set up in expertly decorated grottoes—a natural environment artificially maintained in a "wild" state. Whoever wanted this extraordinary environment to be created in a house that also contained a luxurious private bath next to the obscure *cubiculum* of which we have spoken, and above all was intended to imitate models belonging to the urban aristocracy, was surely a man who did not deny himself the pleasures of life but who sought them tenaciously. In other words, he was a hedonist.

We must thus not be surprised if he had a hole cut in the wall in order to indulge to the maximum in the sexual pleasure offered by the excitement, in his amorous trysts, that these small erotic pictures could offer, all the more so as the ancient sources are clear that they were utilized by the most conspicuous figures of the day and therefore enabled the owner of the house to follow a fashion that was all the rage among the nobles. Indeed, Ovid (*Tristia* 2.521–4) addressed his readers, obviously persons of the upper aristocracy, saying

that *tabulae* with *figurae Veneris* could be found in everybody's house, while elsewhere (*Ars amatoria* II.679–681) he alludes expressly to collections of small pictures depicting a large assortment of erotic positions.

To better specify what, besides fashion, could be the erotic stimulus that such pictures were able to offer, we must concentrate above all on their main feature—they were behind a door. We must not imagine that the covering served to keep them hidden from modest eyes when not in use. We know by now that depictions of copulation, including crude ones, could be found even in public places, just as it is easy to find openly sensual scenes in the "public" rooms of respectable houses. For example, a picture of a nude couple lying on a bed in the presence of a slave was placed doorless in the House of Caecilius Jucundus on the north wall of the peristyle, a place frequented by the entire household, as well as servants, friends and guests (Fig. 70). It would be a serious mistake to think in terms of modesty. In Pompeii, after all, we find representation of pictures with doors as early as the period of the Second Style, that is, in the first century B.C., with mythological scenes or still lifes in the House of the Cryptoporticus, which have absolutely no reason to be hidden. The same occurs at Oplontis, in the Villa of Poppaea, with landscapes or statues, or even in Rome, in the Augustan period, in *cubiculum* B of the Villa della Farnesina (Fig. 75), where the scenes, though certainly erotic in tone, are not crude or scabrous. It must be that the most characteristic element of these pictures, namely the door, had the function of protecting the images from dust or sun or smoke, because they were precious. We should stress that the pictures are easel

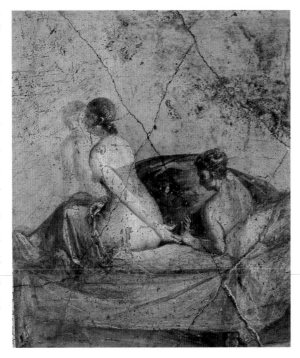

70. Assisted by a slave boy, a woman lifts herself up from the covers where she was lying with a man.
From the north wall of the peristyle of the House of Caecilius Jucundus (V.1.26). Fourth Style. A.D. 62–79. Naples, Museo Archeologico Nazionale, inv. no. 110569.

paintings, on board: very costly, therefore, and deserving of protection. The door, then, evokes first of all an atmosphere of luxury and wealth, which obviously has always constituted a desirable setting for all pleasures, especially the amorous encounter. But over and above this first and particular function, of elevating the material context of the amatory ritual to a more refined and erotically enticing atmosphere (cannot wealth itself constitute an erotic stimulus?), we can easily note how the erotic picture with doors, which can be opened or kept closed, manages also to instill in a woman, or a couple, a feeling of curiosity and then of surprise, given the many possibilities of position that could appear when the doors were opened, as in a sort of erotic roulette.

How effectively these little games were played, if indeed they were, what their rules were, what the subtle pleasure was, we will probably never be able fully to understand. A medallion on a terracotta vase from the Rhône valley, now in the Nîmes museum, shows a woman straddling a man and behind the couple a doored picture of a quadriga drawn by galloping horses (Fig. 69). On another medallion, whose main scene is a woman being taken from behind by a man, who in turn is being penetrated by another man, in a smaller picture with doors we can just make out, despite a considerable lacuna, a pair of galloping horses (Fig. 68). On the previously mentioned mirror now in the Antiquarium Comunale of Rome (Fig. 65), a picture of a couple having clinched in rear-entry intercourse provides a backdrop to a man taking his lady from behind while raising her legs.

Such pictures, both explicitly and figuratively, may have served to give the go-ahead to a game whose rules on the way to make love unfortunately escape us.

One of the pictures in Pompeii's brothel, on the south side of the west wall (Fig. 71), seems to me to be decisive. There such pictures have the additional job of somehow raising the tone of the ambience, evoking a gilded world where love was experienced in refinement. The first of the series of the small erotic pictures that decorate the place shows not a sex act but a couple engaged in kind of foreplay. The man, already undressed and lying on the bed, shows the still fully dressed woman, a *hetaera*, or courtesan, standing next to him an erotic

picture with a door hung on the wall. He points at it with arm outstretched and is probably showing her what to do for him.

If such a scene confirms what Suetonius says, leaving no doubt on the use the most refined citizens of the day made of these paintings, the door necessarily alludes to the element of surprise, which determined, in a particular moment of the encounter, the manner in which the couple should perform the act, in an unbridled pursuit of sexual pleasure.

This is a subtle game, in other words, of the picture within the picture, one that has always allured. In the case of the *cubiculum* of the House of the Centenary we are at the top. Each of the paintings shows a picture with open doors, at the sight of which a couple engages in amorous acrobatics, but they refer especially to the real door in the room which, when open, will reveal to the two lovers on the real bed how best to satisfy their desire for each other.

It is a cerebral game, impeccably put together, that gives us a new key to the conception of eroticism in the Roman world.

71. Scene of a man, already nude and lying on the bed, and a woman, still dressed and standing next to him. He shows her a sexual position illustrated in a doored picture hanging on the wall.
Probably A.D. 72–79. Pompeii, west wall of the brothel (VII.12.18), south section.

VOYEURISM AND EXHIBITIONISM

In speaking of the *cubiculum* expressly conceived for erotic play in the House of the Centenary we mentioned the figure of a slave in the anteroom, whose duties included aiding his master's erotic games. The *cubicularius*, the slave assigned to the *cubiculum*, whose exact job was to stay in the anteroom to attend to the needs of the master resting in the *cubiculum*, does not appear to be entirely extraneous to a certain practice that rendered the couple's amorous dalliance still more piquant and charged with intense erotic nuances: exhibitionism, in direct connection with voyeurism.

In order properly to understand exhibitionism in antiquity, we must forget the meaning it has assumed in the modern era, which is largely the pathological and abusive exhibition of one's genitals to unconsenting persons, usually strangers. Here we speak of a subtler game, exquisitely erotic, consistent, on the one hand, with spying on the sexual behavior or nudity of others and, on the other hand, with the awareness of the persons who are the object of these attentions. The actors take sensual delight in knowing that the desire focussed on them would not offer any release for the object of it. Martial, on the other hand, speaks to us (XI.45) of the little holes deliberately made in the cells of brothels by Peeping Toms to steal a glance at the intimacy of others and of the different behavior that such an occasion might provoke. While not underestimating the erotic value of watching "through the keyhole," the topic ranges over a wider and more varied field, psychologically much more sophisticated.

Slaves—persons without legal status, and therefore considered objects, but still people—lent themselves perfectly to such a game. Just as they could freely dispose of their slaves for sexual purposes, the master and mistress could also formally consider them as little more than domestic animals, under whose gaze it was licit not to feel the slightest embarrassment. It was clear, however, that they were not animals, and as persons were subject to normal sexual urges. This allowed master and slave to concoct extremely erotic

intrigues; the slave could peep at or fantasize intimacy with the object of his unattainable amorous desires, while the master's awareness of the slave's desire, which he was at his leisure to formally ignore, fanned the fires of the master's libido, especially when he was having sex with another partner.

We have seen sketched by Martial the figure of a Lesbia whom we could take as truly emblematic of such licentious passions. Martial also addresses the question from the point of view of the slaves, letting it dissolve into literary myth, referring to the passion some wives showed (XI.104.13 f.): *masturbabantur Phrygii post ostia servi, Hectoreo quotiens sederat uxor equo* ("It was a continual string of hand jobs among the Phrygian slaves behind the door, every time Andromache, in bed, rode Hector, her steed"). Clearly, the presence of the slaves peeking and eavesdropping often extended the bounds of Eros during sex with one's own partner.

The pictures that have come to us from the Roman world speak to us directly about this predilection. It is not rare to find, in pictures showing couples in love, the constant (if disturbing) presence of the male and female slaves, which apparently heightens a scene's erotic charge.

A beautiful painting from the House of Caecilius Jucundus, now in the Museo Archeologico Nazionale in Naples (Fig. 70), shows a nude woman rising from the covers where she was lying with her partner; she turns to a young slave who appears ready to obey her orders. In one of the scenes discussed earlier of the couples banqueting in the House of the Chaste Lovers (Fig. 39), a maid attempts to revive, by fanning, a man flat on his back in a drunken stupor. In other scenes from the same house, male and female slaves are present. Slaves engaged in various duties while couples reclining on the bed concentrate on carnal pleasure is almost a constant in the erotic *cubicula* pictures from the Villa della Farnesina in Rome (in the Museo Nazionale Romano), which may have belonged to the daughter of the emperor Augustus (Figs. 72–75; cf. Fig. 76). In still other

MASTURBABANTUR PHRYGII POST OSTIA SERVI, HECTOREO QUOTIENS SEDERAT UXOR EQUO

IT WAS A CONTINUAL STRING OF HAND JOBS AMONG THE PHRYGIAN SLAVES BEHIND THE DOOR, EVERY TIME ANDROMACHE, IN BED, RODE HECTOR, HER STEED.

MARTIAL, *EPIGRAMS* **XI. 104, 13f.**

Pompeian paintings, no longer preserved but known from nineteenth-century drawings (Figs. 77–80), it is not rare to find, alongside couples depicted in crude scenes of coitus, servants who contemplate the goings-on while they carry food or drink.

Where the game of peeking and being peeked at appears without any ambiguity at all and, in fact, presents itself as a decisive example of erotic art, is on the magnificent silver Warren cup, made in the Augustan age (Fig. 44). On each side of the cup is a very explicit scene of sodomy on richly adorned beds, one involving two men, the other a man and a boy. But the most interesting detail, on side A, is the little slave boy who peeks around the half-opened door to the room to watch unseen the acts of the two men swept

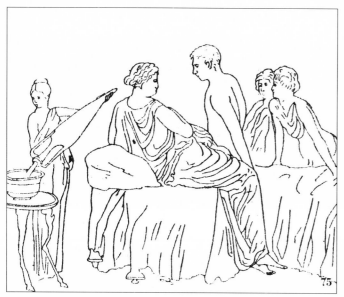
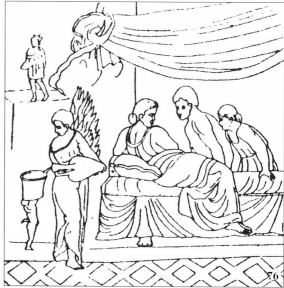

72. 73. 74. 75. Pictures from the Villa della Farnesina.
From Rome. Very late Second Style. ca. 19 B.C. (from Reinach, *Répertoire des peintures*). **72.** Small painting in the upper zone of the left wall of *cubiculum* D with seated couple on the bed assisted by three servants, pl. 326,7, inv. no. 1187. **73.** Small painting in the upper zone of the right wall of *cubiculum* D with couple lying on the bed attended by two servants, pl. 326,6, inv. no. 1188. **74.** Small painting in the upper zone of the right wall of *cubiculum* D with couple on the bed assisted by a servant, pl. 326,5, inv. no. 1188. **75.** Picture with doors

in the upper zone of the left wall of *cubiculum* B showing couple on the bed assisted by three servants, pl. 326,9, inv. no. 1128.

76. Polychrome mosaic *emblema* depicting a couple on a bed protected by a canopy and attended by two servants.
From Rome. Villa di Centocelle. ca. 20 B.C.–A.D. 20 (from Reinach, *Répertoire des peintures*, pl. 267,1).Vienna, Kunsthistorisches Museum, inv. AS II 9.

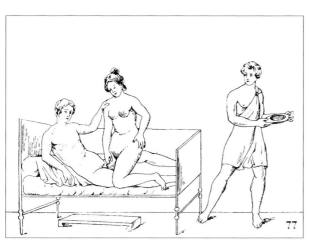

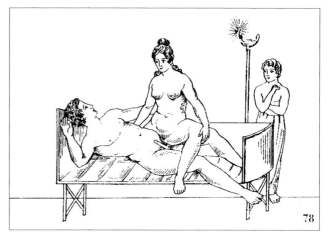

away by their passion. It is clear that the episode is not casual, but deliberate and sought. The fine workmanship of the cup is quite clear in the precise depiction of the penetration in progress; with clearly erotic intent, the object itself was conceived as a means for inflaming lust. The figure of the little slave merely increases and completes the atmosphere of sizzling eroticism in which the scene takes place. That the carnal act occurred exclusively

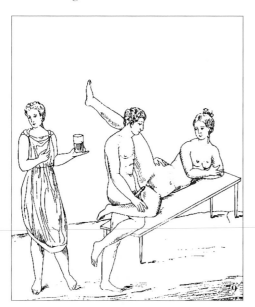

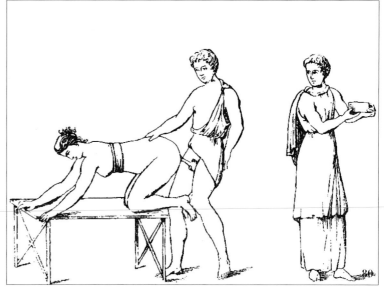

77. 78. 79. 80. Reproductions of paintings.
From the Vesuvius area. First century A.D. (from Barré, *Musée Secret*). Reproductions of paintings formerly in the Real Museo Borbonico and now lost.

77. A couple in bed in the presence of a servant, pl. 22.

78. A couple in bed observed by the *cubicularius* by the light of a candelabrum, pl. 23.

79. A couple making love, attended by a maidservant, pl. 30.

80. A couple making love, attended by a maidservant, pl. 32.

between men neither adds nor detracts from this argument; the Romans considered such intercourse, in the active role, to be quite natural, beyond reproach and even conventional.

An erotic painting found at Pompeii in the summer *triclinium* of the house at I.13.16, and now unfortunately poorly preserved, shows a door suggestively left ajar behind a couple in bed in a position worthy of a contortionist. The evident reference is to the possibility that such imaginative love games were observed by others (Fig. 81).

Another unusual element of eroticism, which also seems to have been the prerogative of the Roman world, and in some way also connected with exhibitionism, appears to

be that of the almost uncontrollable need to talk about one's pleasure, to involve others in it.

So subtle a game seems to spare no one, man or woman, since it is easy to find on the walls not only boasting of the sexual prowess of the writer—both male and female—but also smug compliments, or criticism, of the amatory qualities of the partner.

"Mirtis, you really know how to suck it" (*CIL* IV 2273), we find written in the brothel, and "Rufa, may you always be well, how well you suck it" (*CIL* IV 2421) in the corridor of the theater. But there is criticism as well: "Sabina, yes, you suck it, but you don't know how to do it really well" (*CIL* IV 4185), read in the House of the Silver Wedding.

81. Pompeii, picture from the summer *triclinium* of the house at I.13.16.
Note especially the detail on the left of the partially closed door of the room in which a couple are having sex on a bed covered with heavy drapery and a canopy.
Fourth Style. A.D. 62–79 (Photo S.A.P., A 1529).

There is praise for potent males: "Victor, may you be well since you screw so well" (*CIL* IV 2260 with addenda, p. 216), written again in the brothel. But for those whose performance is poor, there is only ignominy: "Jucundus does not know how to fuck" (*CIL* IV 8715b), is the pitiless announcement of a graffito found in the Great Palaestra.

If boasts and trumpeting one's own praises belong to the usual male ritual, sometimes a man left a detailed list of his male and female prey, like notches on a belt (*CIL* IV 8897: "Ninfa, screwed; Amomo, screwed; Perennis, buggered"); others sing the praises of their abilities (*CIL* IV 8767: "Few women have known that I, Floronius, great cocksman, soldier in the VII legion, was here: and I will do me only six"). It is, however, worth the trouble remembering that even some women enjoyed publicizing their extraordinary sex drive. For every Restitutus, therefore, who says he seduced "often many girls" (*CIL* IV 5251), where the juxtaposition of "often" and "many" offers a perfect synthesis (although ridiculous for us) of his stature as seducer, and for every braggart who, right in the brothel, boasts of having had "many girls," there are a Romula and an Euplia, who do not hesitate to claim to have satisfied thousands of men (C. Giordano, "Le iscrizioni della casa di Fabio Rufo," *Rendiconti dell'Accademia Napoletana*, n.s., XLI [1966]: 78, no. 19; *CIL* IV 2310b).

True erotic drive, however, for all it may appear strange to us, is that irrepressible need to write about one's own sexual encounters, during or just after. Sharing one's satisfaction with others was an indulgence Romans were unable to resist. The pleasure of saying "I fucked, I fucked well," from which the ancient Pompeians did not shy away, should therefore itself be regarded as an erotic manifestation, which completed and perfected, in the external relationship with others, the personal sexual pleasure one enjoyed. The externalizing of one's own enjoyment, therefore, became the subtle mainspring of sexual satisfaction and of self-satisfaction. As such it becomes particularly interesting for us in that it shows us an eroticism connected not to sexual desire, and therefore "before," but to the satisfaction of that desire, and therefore an eroticism "of after."

How else can we define, except as erotic satisfaction, a woman's desire to write in the brothel, with full satisfaction: *Fututa sum hic*, "I was fucked here" (*CIL* IV 2217)? Another wishes to make known the constancy of her application: "Every day I lick off Piramus" (*CIL* IV 10041). Another feels she cannot say no: "Order your member: it's time for love!" (*CIL* IV 1938 with add. pp. 213, 704). It is a satisfaction, however, that at times seems to pervade third parties as well, ready to tell of instances in which the dedication of a woman appears capable of self-sacrifice in order to persevere in giving particular pleasure to a man: "Veneria sucked the cock of Maximus through the whole grape harvest, leaving both her holes empty and only her mouth full" (*CIL* IV 1391).

Indicative of how difficult it was to refrain from recounting one's amatory feats, an almost unfailing corollary of the love act, is this distich found in the Villa of the Mysteries, in which the aspiring poet would like to free his poetry from the base acts committed, but he can't quite manage it: "Here I pierced the lady abruptly, spreading her behind, but foul it has been to write this in verses"(*CIL* IV 9246b).

We really scale the heights of this type of exhibitionism in the Stabian Baths, where an inscription written in charcoal reads like a sort of play-by-play report of an act of oral sex. An *irrumator* first gives instruction to his partner on how the mouth should slide along his shaft, then describes the pleasant effects the action has on him (*CIL* IV 760 with add. p. 196): *Oblige mentulam, mentlam elinges ... Destillatio me tenet* ("Go down with your mouth along the shaft, licking it, then still licking withdraw it upwards. Ah, there, I'm coming!").

It would almost seem that the true pleasure, more than the enjoyment of the sexual act itself, comes from talking and writing about it as it happens. Another way of understanding what is erotic during the act itself: whatever makes us smile.

LOOKING AT NUDITY AND LOOKING AT ONESELF DURING LOVE

Still on the topic of "during" we must linger on two other aspects that we know aroused erotic drive in the Roman world, both also connected with the sense of sight.

As we have said apropos of the sense of hearing with respect to music, for the sense of smell, too, we can infer the erotic stimuli, since we know the almost inordinate use that was made at the time of perfumes and essences, which the ancient authors tell us were prohibitively costly. According to Pliny the Elder (*NH* 13.20 f.), for example, perfumes, unlike such durable luxuries as jewels, were quickly used up and could not even be left to one's heirs. To refute this, it should be noted that many women who died at Pompeii while they tried to escape from the city during the dramatic phases of the eruption took with them along with their jewels in little chests also *unguentaria* and *balsamaria* (perfume flasks), which they considered equally precious. Martial mentions the custom of offering guests perfumes with which to anoint themselves during banquets and exposes to ridicule persons who wore too much perfume. There is no doubt, however, that the arts of seduction were practiced also with perfumes and that they, therefore, had a bewitching effect on those who, under the right conditions, were inebriated by them.

Since we are even less able to speak of the senses of touch and taste as instruments of reception of erotic atmosphere, it is better to concentrate on situations of visual impact that the culture and the sentiment of the times perceived as erotic, also because they contain some surprises. Of note, culturally, is a much more marked sensibility than we could today sustain regarding nudity and the sight of our own bodies during sex. The common sense of modesty of the time affected the broader strata of the population and was officially considered normal. In fact, it was deemed a form of immodesty for a woman to show herself completely nude to her partner. Likewise, the sex act, even in the intimacy of the bedchamber, had to be consummated in the dark so that it would not seem dirty.

Any number of passages from the ancient authors could be cited in support. We

prefer, by way of example, to be guided by Martial, who in an epigram has a husband speak thus of his wife (XI.104,5–8): *Tu tenebris gaudes: me ludere teste lucerna / et iuvat admissa rumpere luce latus. / Fascia te tunicaeque obscuraque pallia celant:/ at mihi nulla satis nuda puella iacet.* ("You enjoy it in the dark: I like the lamp to watch us while I bust my sides in the light. You wear too many clothes to bed, but for me a woman can't be too bare.").

And yet Martial (III.87), sarcastically advising a woman to cover her mouth if she has to be ashamed of some part of her body as wicked, implicitly confirms the widespread sentiment of modesty, which, true or false, formally involved the women in the traditional vision that the social morals insisted on having of them. He also (III.72) mocks a woman who, although seeming to consent to his amorous offers, out of modesty does not want to bathe naked with him.

Propertius, for his part, states that "it is pointless to ruin love by movements the eyes cannot see" (II.15, 11 f.: *non iuvat in caeco Venerem corrumpere motu:/ si nescis, oculi sunt in amore duces*) and they must be satisfied with the sight of love (II.15, 23: ... *oculos satiemus amore).* His sweetheart, although she has afforded him a wonderful night of sensual delight, does not want him to see her naked, and he must actually struggle with her in the dark to get her clothes off (II.15, 4–6: *Quantaque sublato lumine rixa fuit! / Nam modo nudatis mecum est luctata papillis, / interdum tunica duxit operta moram).* If she insists on wanting to go to bed fully dressed, he will get down to business anyway (II.15, 17 f.: *Quod si pertendens animo vestita cubaris, / scissa veste meas experiere manus).*

Ovid's Corinna, too, is recalcitrant in revealing to the poet the splendor of her nudity (although subsequently she is capable of victoriously yielding to him) before lying with him (*Amores* I.5, 9–25). It mattered not that the room was swathed in that discreet half-light so dear to bashful maidens, for whom the dark is the ally of modesty (*Amores* I.5, 7 f.: *illa verecundis lux est praebenda puellis, / qua timidus latebras speret habere pudor).*

Not seeing one's partner in bed, moreover, becomes an outright commandment in the myth of Amor and Psyche, even though it presents more complex motives and certainly deep philosophical speculation. In the well-known fable, recounted at length by Apuleius in his *Metamorphoses* (4–6), Psyche sees Love take flight, when, against his prohibition, she draws near to him with a lighted lamp, thus seeing his face after long and happy nights of pleasure together in the total darkness.

Many painted love scenes in Pompeii serve all the more to illustrate our intent where we see that the woman is often not completely nude and is sometimes even wearing precious gems. This serves in fact to bring the scene into the "aristocratic" repertory of refined amorous trysts, raising the tone of the ambience.

It is also true that many pictures show women engaged in dizzying copulatory exploits wearing the *strophium*, or breast band (the lingerie of the time), used to support rather than cover the breasts. That illustrates the erotic charge unleashed even then by lingerie, which helped women to look their best for their lovers.

But let us not forget that Ovid's advice for women on the sexual positions (*Ars amatoria* III.771–788) is specifically intended to explain the most advantageous way for women to offer themselves to titillate the visual pleasure of the man in consideration of their physical endowments. In other words, the suggestions are not for enjoying the physical pleasure more but for offering the best view of oneself to one's lover.

We understand well, at this point, how the view of one's lady in the nude constitutes a trigger for the erotic factor (Ovid, *Amores* II.15, 25: *te nuda mea membra libidine surgent*), counterbalanced in the woman by the pleasure deriving from feeling herself admired and intensely desired by the man who showered his satisfied attentions on her.

TU TENEBRIS GAUDES: ME LUDERE TESTE LUCERNA
ET IUVAT ADMISSA RUMPERE LUCE LATUS.
FASCIA TE TUNICAEQUE OBSCURAQUE PALLIA CELANT:
AT MIHI NULLA SATIS NUDA PUELLA IACET.

YOU ENJOY IT IN THE DARK:
I LIKE THE LAMP TO WATCH US WHILE
I BUST MY SIDES IN THE LIGHT.
YOU WEAR TOO MANY CLOTHES TO BED,
BUT FOR ME A WOMAN
CAN'T BE TOO BARE.

MARTIAL, *EPIGRAMS* XI. 104, 5-8

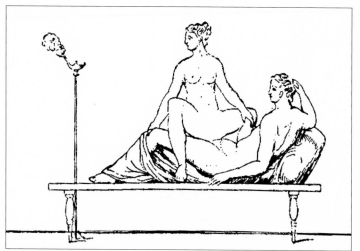

A uniquely erotic value is thus acquired in details to be seen in some explicit Pompeian sex scenes, where, for example, we see candelabra with lighted lamps next to beds on which couples are engaged in furious lovemaking (Figs. 66, 78, 82, 84), while on some of the Rhône valley medallions the lamp is directly held in the woman's hand, or even the man's, as they take their pleasure (Fig. 83). In another small Pompeian picture, we can make out the branch of a tree from an opening on the back wall of a room in which the two lovers on the bed play a similar game, which thus alludes to an act consummated in the light of day (Fig. 85).

This picture suggests that there was an erotic component even in the architectural conception of some rooms in the wealthy houses of Pompeii, such as the House of Julius Polybius or the House of the Marine Venus (Fig. 86). In these rooms, the wide opening of the window, facing the garden, is placed a few centimeters above the floor, which can be explained logically only by observing how it was possible to contemplate the spectacle of nature, "captured" in the garden of the house, while lying comfortably in bed. It does not seem at all far-fetched to imagine that whoever wanted to create for himself rooms with such windows at bed-height had also thought about how such a pleasure could be made

82. Picture of a couple making love by the light of a candelabrum.
Reproduction of a painting in the Real Museo Borbonico and now lost. From the Vesuvius area. First century A.D. (from Barré, *Musée Secret*, pl. 25).

83. Terracotta medallion with sex scene, appliqué for a vase.
As on other similar medallions, note that the woman holds a lamp to light the scene.

From the Rhône valley. Second to third century A.D. (from Marcadé). Arles, Museum.

84. Picture of a couple having sex by the light of a candelabrum.
Probably A.D. 72–79. Pompeii, south wall of the brothel (VII.12.18), east section.

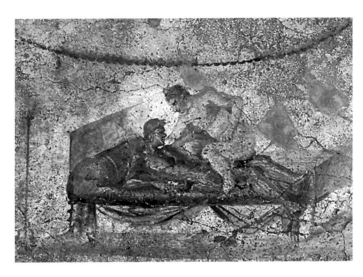

still more vivid if he was not lying in bed alone.

It is more disturbing to examine the question relative to the contemplation of one's own body and that of one's partner during the act, even if the evidence from Pompeii does not, at the moment, offer us precise information on the subject. We discover from reading the sources that the mirrored room is not at all a modern invention, even though at the time mirrors were certainly not available to just anybody, both for their cost and for the difficulty of finding them. Those discovered at Pompeii have been of such valuable materials as polished silver or even obsidian and were mounted directly in the wall. Glass mirrors have not turned up; they first appeared in Ptolemaic Egypt but seem to have spread only in the second to third century.

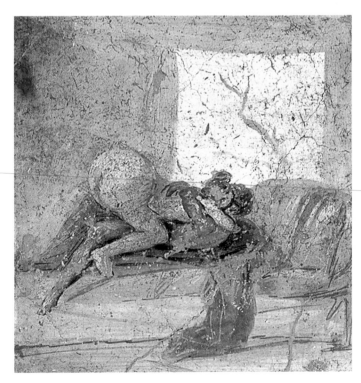

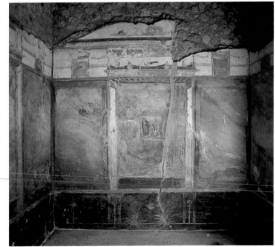

85. Picture of a couple having sex in a room flooded with light from a low, wide window open onto the garden.
From Pompeii. Fourth Style. ca. A.D. 45–79. Naples, Museo Archeologico Nazionale, inv. no. 27684.

86. Pompeii, day *cubiculum* (11) of the House of the Marine Venus (II.3.3).
Note on the right the wide window open on the garden at the height of the bed.
First century A.D.

Suetonius recounts (*Lives of Illustrious Men: the poets* 24.62–64) that the poet Horace "was overly fond of indulging in the pleasures of Venus. In fact, in a bedchamber full of mirrors he arranged his strumpets so that wherever he cast his gaze he could see reflections from different angles of the coitus in progress."

Seneca (*Natural Questions* I.16) leaves us the awesome portrait of a certain Hostius Quadra, who died at the same time as Augustus, who had convex mirrors fabricated to enlarge the reflection, so a finger looked longer and thicker than an arm. Since he loved to be penetrated by other men, he arranged the mirrors so that he could watch the movements of his lover as he dealt his thrusts and, seeing his member exaggerated beyond measure, "he took pleasure in this as if it really were of such dimensions." This man, who also recruited his lovers in the public baths, choosing them strictly on the basis of penis size, was attracted no less by the representation of reality, feasting his eyes on the reflected image of what was being done to him. Likewise, thanks to the mirrors, he could watch himself at work as he leaned over the genitals of others, where he would otherwise have been able to see only the groin. He could also command a full view of what was happening when he shared himself out between a man and a woman at the same time. In this way, he said, he could view what his position in the various carnal configurations would otherwise have prevented him from seeing, so that nobody could think that he did not know what he was

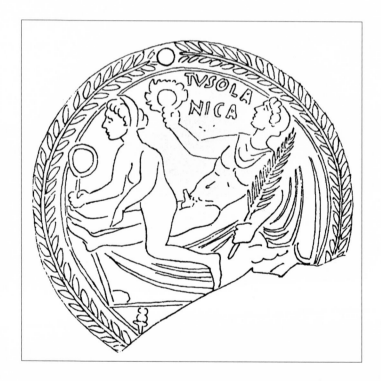

87. Drawing of a terracotta appliqué medallion with scene of after-play.
The woman watches her partner's movements in a mirror. The palm of victory shows he is a champion, but he is crowning the woman with a wreath of her own, saying, as in a comic strip: *Tu sola / nica* ("You alone conquer me"). From the Rhône valley, Second to third century A.D. (from Wuillemeier and Audin).

doing. The mind boggles at the idea of what his perversion would have been if it had been kept within the bounds of the real. The mirrors made the size of the things incredible. If there had existed sexual members that large, he would certainly have used them for his pleasure. Since they did not exist, he indulged himself at least in the illusion: "My vice sees more than it actually receives and it marvels at what it is able to take in."

Confirmation of how mirrors were actually used as instruments to arouse the libido comes from another medallion from the Rhône valley (Figs. 87-88) which represents a woman who seems to have just finished straddling a man lying beneath her, but her position is unlike that in similar scenes in that she is not facing the man but has her back to him. The interesting detail is that in her right hand the woman holds a mirror that she evidently used while taking her pleasure. While she had her back to the man—a new position, an unusual variation—she could spy on him, relishing both the grimaces of pleasure on his face and the pelvic movements of penetration, while maintaining her total control of the situation. She was thus able to impose the most appropriate rhythm, while enjoying the view of the details of the act. That her expedient produced the desired effects is confirmed for us by her partner, who is depicted as a frequent victor with a large victory palm in his left hand; with his right hand he raises a wreath to crown the lady, while exclaiming, as in a comic strip: "You alone conquer me."

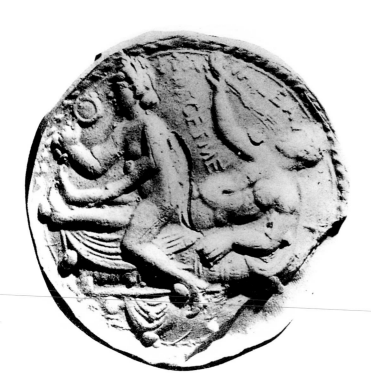

88. Terracotta medallion with sex scene.
The woman uses a mirror to watch her partner, to whom her back is turned. He says, as in a comic strip: *Valeas / ita / decet me* ("May you be well! That's how I like it").
From the Rhône valley. Second to third century A.D. (from Marcadé).
Vienna, Kunsthistorisches Museum.

MANIFESTATIONS IN THE SACRED SPHERE

The most unusual aspect of eroticism in the Roman world for us, and also the most shocking, is the way it is expressed in the sacred realm. Framing this aspect will help us to understand the very conception of sexuality in a world that had not yet received the Christian message, whose interpreter and propagator it would become.

Sexuality was viewed and practiced in an absolutely positive light. Though it was regulated by laws or customs concerning the way it related to society, no one disputed the legitimacy of the goal of sexual gratification. The collective sentiment, not yet educated to the complex and variously structured ethical system that would develop within the Christian vision of life, was not at the time able to embrace concepts such as that of the mortification of the flesh, nor to consider sex per se as sin. Even the vestal virgins, whom the Roman religion required to be virgins to favor with their adamantine purity the execution of those public rites placed at the center of the well-being of the State, had to honor, under the form of an apotropaic simulacrum (Pliny, *NH* 28.39), that phallus of which they were not to have any knowledge in the flesh. Restrictions on free sexual activity were, in fact, as mentioned above, exclusively seen in relation to values of another kind, which the society of the day considered important and therefore safeguarded. Without going into detail on this topic, which was very different from ours, and for that matter broadly and well illustrated in works specifically dedicated to it, let only one example suffice to clarify the concept. If it was forbidden to sodomize a free-born boy, that was because, in light of the concept of "active element," it was important for the social apparatus to safeguard its own citizens in their formative years. The prohibition did not apply to sodomy per se, which, if performed on a young slave, for example, was not only a widely accepted practice but was considered completely legitimate and not even blameworthy.

The positive side of sex, including its procreative function, was regarded as a magic

89. **Marble sarcophagus with scene of Bacchanal.**
Detail of faun sodomizing himself.
From the Farnese collection. Second half of the second century A.D.
Naples, Museo Archeologico Nazionale, inv. no. 27710.

phenomenon, as we have already seen. Sex therefore occupied a place in the religious sphere that gave divine power to the many individual forces determining and influencing the creation of men and the events linked to it.

In Pompeii, however, Venus, the tutelary goddess, is immortalized in hundreds of pictures. In some she exhibits fuller characteristics of her divine royal majesty, in others she represents the union of one of the greatest divinities of the Roman pantheon with the indigenous Italic goddess of the fertility of nature, called Venus Physica by the Pompeians. As Lucretius, putative native son, would have said, Venus is not only *hominum divumque Voluptas*, "pleasure of men and of gods" (*De rerum natura* I.1), but also the very guide of nature (I.21), she who induces every living being to the propagation of life and ensures that the fields are full of fruits (I.3–5). It is she, supernatural force, who lights the flame of love: *Haec Venus est nobis*, "this Venus is in us" (IV.1058).

Love thus brought back to the divine sphere of the forces that govern the life of men, and its sacral essence recognized, can also be seen decidedly as one of the moments in which, in well-defined functions and ceremonies, the religious practice was made clear. The relationship with the divine, in fact, according to the cornerstones of the true Roman religion, was far from intimist; it came to be regulated in the context of precise obligations, of established and immutable rites, of actions to perform in an explicit way. The god addressed, who had a well-defined and circumscribed sphere of power, granted his or her favor in equally well-defined circumstances.

On the other hand, the practice of sacred prostitution was widespread in the ancient world, especially in the East, and was also found in the Greek world or Greek culture, for example at Corinth or Eryx. At Locri, at the Centocamere, in the U-shaped stoa and its continuation, where identical cells follow one upon the other in a sanctuary dedicated to Aphrodite, it has been possible to recognize the place where sacred prostitution was practiced, amply recorded in the sources. The courtesans, who celebrated the encounter of love in the exercise of a rite that foresaw the carrying out of canonically normative formalities, were true

ministers of the goddess, who used them to lavish upon men, through carnal pleasure, her own fertile and fertilizing virtues.

Also in the sphere of Roman religiosity we glimpse ritual moments in which sexual activities were exalted into the sphere of the mystic. Thus, in the very ancient agrarian rites connected with the fertility of the earth, the ploughed-up clods were symbolically fertilized in ceremonies of very strong sexual connotation. Numerous are the divinities connected to sex and fertility who the Roman world honored in the course of its history. Among the gods of the *indigitamenta*, the name itself of Subigus, who was accompanied by Prema and Pertunda, contains a clear indication of his phallic characteristics. Equally phallic were the nuptial divinities, such as Talassius. The cults of fertility goddesses, such as the Bona Dea, were also phallic. As at Lampsacus, homeland of Priapus, according to Martial (XI.63, quoted above), the vestal virgins, the virgin priestesses considered the very guardians of the religious rituality of Roman society, had to worship the god Fascinus, the deified personification of the phallus, according to the testimony first recorded by Pliny, and they also participated in the nocturnal worship of the Bona Dea. If we keep this picture in mind, it may not seem so far-fetched to seek in the religious sphere sexual behaviors that could have heavily erotic connotations precisely because they were performed in a sacred context, in which passions become heroic.

RELIGIOUS FESTIVALS

The festival of the Floralia was celebrated in Rome between April 30 and May 3 to welcome the spring and with it the reawakening of all nature. This was the festival in honor of Flora, with games in the Circus Maximus and spectacles characterized by the utmost licentiousness. Echoes of the celebration of such a *Sacre du Printemps* are also found among the Nordic peoples, as, for example, in the festival of Vappu, which the Finns celebrate on May 1, at the melting of the snows, with special costumes and sometimes lewd behavior. During the Floralia, the Romans, if

they dressed at all, wore multicolored clothing, which was otherwise prohibited (cf. Martial I.35, 8), and, ritually, they let loose, in a sexually characterized manner, to celebrate the Fasti of the divinity. Martial makes the Floralia the keystone of the comparison that he sketches, in the introduction to the first book of his *Epigrams*, to justify the licentiousness of many of his writings (*epigrammata illis scribuntur qui solent spectare Florales*, "the epigrams are written for those who attend the rites of Flora"), immediately after speaking of the *sacrum* dear to the joyous Flora. Juvenal, on the other hand, in his long, angry tirade against women in his sixth *Satire*, tells, not without disdainful acrimony—and doubtless leaving us the suspicion that he is not in good faith—of the orgiastic fury that possessed the women during the rites in honor of Bona Dea (6.314–334):

We know the Good Goddess's secrets, when loins are stirred
by the flue, when Priapus's maenads, wine-flown, horn-crazy,
sweep along in procession, howling, tossing their hair—
ah, what a vast mounting passion fills their spirits
to get themselves mounted! Such lustful yelps, such a copious
downflow of vintage liquor splashing their thighs!
Off goes Saufeia's wreath, she challenges the call-girls
to a contest of bumps and grinds, emerges victorious,
herself admires the shimmy of Medullina's buttocks:
so the ladies win all the prizes—skill rivalling pedigree.
No make-believe here, no faking, each act is performed
in earnest, the genuine article, fully guaranteed
to warm the age-chilled balls of a Nestor or a Priam.
Delay breeds itching impatience, boosts the pure female urge,
and from every side of the grotto a clamorous cry goes up:
'It's time! Let in the men!' If a lover's sound asleep,
his younger brother is told to get dressed and hustle along.
If they draw a blank there, they try slaves. If enough slaves cannot be found,
the water-carrier's hired. If they can't track him down, either,
and men are in short supply, they're ready and willing to go down on all fours and cock their dish
 for a donkey.
(Translation: Peter Green, *Juvenal: The Sixteen Satires*, 3rd ed., 1998. Reproduced by permission of Penguin Books Ltd.)

Undoubtedly such lust was unleashed by the excitement aroused by performing a religious rite; this was certainly why aristocratic Roman women became more brazen (and how much more!) than vulgar prostitutes, prepared to do anything to satisfy their own libido. Juvenal himself makes no mystery of it, recriminating (6.335 f.): "If only the rites of our ancestors or at least public rites were free from such infamies!"

That behaviors of this type went beyond the bounds of every tolerance during religious festivals is documented by the vast literature circulating regarding the Bacchanalia, even though the Roman Senate had already banned them in 186 B.C., after bringing charges against 7,000 persons (Livy 39.8–19). Such excesses, caused by excitement carried beyond the extreme confines of paroxysm, reverberate in the semantic meanings of the names of those who abandoned themselves during the festivals of Dionysus-Bacchus to the sacred frenzy of the orgiastic cult. Maenads, "those who go into a frenzy," Thyades, "the possessed," Clodoni, "those

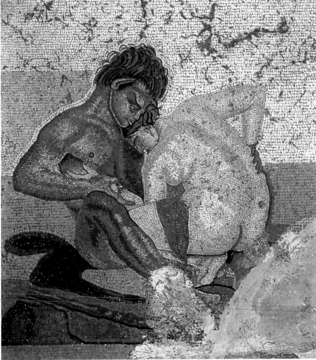

90. Painting of satyr grabbing a maenad.
From Herculaneum. First century A.D. Naples, Museo Archeologico Nazionale, inv. no. 27699.

91. Polychrome mosaic *emblema* depicting foreplay of a satyr and nymph.
From Pompeii, *cubiculum* 28 of the House of the Faun (VI.12.2). First Style. Second half of the second century B.C. Naples, Museo Archeologico Nazionale, inv. no. 27707.

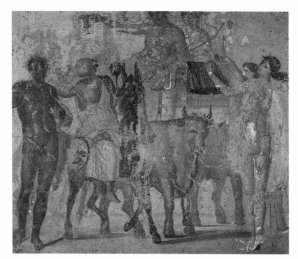

who scream," are appellations that give a good idea of the erotic exaltation that took hold of these women, to the deafening sound of cymbals, drums and flutes used to celebrate the rite. And scenes and depictions of maenads paired with satyrs, typical figures of the Bacchic procession, or being pawed by them, are among the recurring motifs of the whole cross-section of Pompeian figurative imagery (Figs. 61, 90–91). A marvelous picture of the Bacchic *thiasos* from the House of M. Lucretius Fronto (Fig. 92) shows a maenad rapt in an orgiastic dance. Another, from the House of the Vettii, shows Pentheus, the Theban king who dared to oppose the celebration of the god in the mysteries, killed by his own mother, who, possessed and beside herself with mystic exaltation, took him for a boar and tore him limb from limb (Fig. 93). A second-century sarcophagus, now in Naples (Fig. 94), is adorned with a Bacchic scene (the reference is to the life beyond death assured by the god) in which we see, next to a maenad gone mad with ecstasy, a satyr who uses a herm with an erection to sodomize himself (Fig. 89). A sculpture group from the Villa of the Papyri, in Herculaneum, shows Pan, another disturbing figure of the procession of the god, having sex with a goat (Fig. 95). Deference to the god permitted the attainment of heights of erotic exaltation that we today can hardly imagine occurring in a religious context.

92. Painting of the triumph of Dionysus and Ariadne with maenad dancing frenetically.
End of the Third Style. ca. A.D. 35–45. Pompeii, south wall of the *tablinum* of the House of M. Lucretius Fronto (V.4.a).

93. Painting of Pentheus torn apart by Bacchants.
Fourth Style. A.D. 62–79. Pompeii, wall east of the *oecus* (n) of the House of the Vettii (VI.15.1).

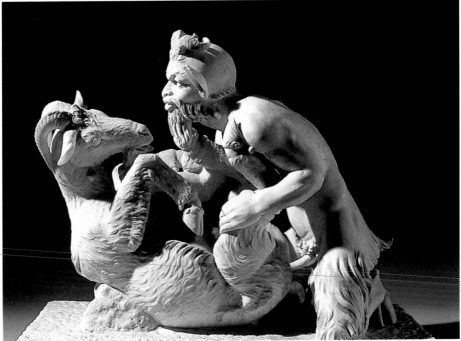

94. Marble sarcophagus with scene of Bacchanal.
From the Farnese collection. Second half of the second century A.D.
Naples, Museo Archeologico Nazionale. inv. no. 27710.

95. Marble sculpture of Pan having sex with a goat.
From Herculaneum, large peristyle of the Villa of the Papyri. Roman
copy of Greek original. Second century B.C. Naples, Museo
Archeologico Nazionale. inv. no. 27709.

FERTILITY RITES

Just as surprising to our eyes are those female initiation rites, or rites that celebrate and invoke female fertility, albeit in a manner that for us is evanescent and difficult to bring into focus. Nevertheless, the marked erotic component that was doubtless inherent in such rituals should be taken into account. Plutarch recounts (*Life of Romulus* 21.5) that during the festival of the Lupercalia, the Luperci, priests of one of the oldest priestly colleges, ran wildly through the city streets, completely nude except for a loincloth, and struck passers-by with the whips they carried. Women, he says, were delighted to submit to the lashes, and indeed sought them out. The belief was well entrenched that whipping helped fertility; in the late Republic, sterility was a legitimate reason to repudiate a wife.

Still more interesting is what we know about the very ancient rite in honor of the god Tutunus Mutunus, the personification of the male sexual organ, to which women about to be married submitted. It took the form of sitting astride the *fascinus*, a reproduction of the male organ, perhaps even with penetration. The most meaningful references with regard to this practice may come from Pompeii. An inscription painted in red along the Via Stabiana (*Reg.* IX, *ins.* 1, between houses 13 and 14) beneath a terracotta bas-relief of a phallus painted red on a blue background reads (*CIL* IV 950): *Ubi me iuvat, asido* ("It is beneficial to me and I shall sit on it"). Still more explicit is another inscription, in which the reference becomes, if possible, even clearer, although it could be in this case a joke and refer not to a simulacrum but to a real male member (*CIL* IV 1940 with add. p. 704): *Arescusa prudente[r] / sumsit sibi casta muthunium* ("Arescusa, who was a virgin, cautiously lowered herself onto the snake").

The mention of the virginity of Arescusa (*casta*), the fact that she is the protagonist of the insertion of the member (*sumsit sibi*), the pointing out of her doing so with care (*prudenter*), the calling the phallus *muthunium*, with evident reference to the god Tutunus Mutunus, give us clear circumstantial clues, beyond the specific and incidental meaning of the inscription, of this religious female initiation to the revelation of the values and practices of sexuality.

ARESCUSA PRUDENTE[R]
SUMSIT SIBI CASTA MUTHUNIUM

ARESCUSA, WHO WAS A VIRGIN, CAUTIOUSLY
LOWERED HERSELF ONTO THE SNAKE

CIL IV 1940

On the other hand, the classical world has left us explicit evidence of this extremely ancient practice.

A number of Greek red-figure vases (e.g. Fig. 96) bear scenes of women lowering themselves onto, or sucking, large dildoes, often without any other context.

If, however, the Pompeian inscriptions only indirectly enable us

to understand the eroticism inherent in such situations, the most famous initiation scene known, thanks precisely to its own exultation of eroticism and its extremely strong charge of inebriating sensuality, will transport us directly into the world of the religious mysteries related to women's rites of mystic knowledge of the god. Although the universally known scenes in the so-called Room of the Mysteries, in the Villa of the Mysteries, are difficult to interpret, the force of their colors and the vibrant music that issues from the hammering succession of images allow even a modern observer to sense the atmosphere of mysticism that shroud the initiate. As the ritual proceeds, unfolding between the unreal, the magic, and the actual performance of the effective practice of prescribed gestures and formulas, the woman is led to the awareness of the essence of the god, in a crescendo of erotic connotations that become gradually ever more palpable, until the paroxysm at the moment of the uncovering the *mystica vannus*, the winnowing basket in which the phallus is kept.

The life-size frieze of the Villa of the Mysteries will probably never reveal its real meaning to us moderns. We no longer have the means to understand the complex symbolism, and any interpretation that we give it seems like guesswork. And yet the suggestive force that emanates from the figures is so powerful that these paintings, though unfathomable, comprise one of the greatest documents the Roman world has left us. As on a stage, a series of life-size figures seem

96. Attic red-figure kylix with scene of women using dildoes.
ca. 480 B.C. Formerly in the Castellani collection (from Keuls).

to move ritually in a dimension without time in which the true and the unreal mingle, and where myth is intimately bound to reality. Regardless of their meaning, even the sequence in which the scenes should be read is debated and uncertain. However, it is preferable to read those on the lateral walls in parallel, having them converge on the central scene with the ecstasy

of the god on the back wall. The evocative power of these images, which appear as *emblema* and synthesis of a civilization and its culture, leaves us truly enchanted, suggesting to us to project the pictures into a dream dimension in which the protagonist is the seated matron (Fig. 97), bride and priestess of the cult, who meditates on the developments of a scene that is all instantaneously present to her mind.

The episodes associated with the ritual and sacred initiation of the woman to the mysteries of the god through knowledge of the male sex organs—seen as points in a dimension to which precise time sequence is irrelevant—are fused in parallel with the epiphany of the god at the climax of the ecstasy, between delirium and the mystic exultation of the various members of his *thiasos*. Even in the first scene, in which a handmaiden helps prepare an initiate for the rite (Fig. 98), reality is superimposed the symbolic presence of two cupids, proselytes

97. The seated matron.
Early Second Style. ca. 70–50 B.C. Pompeii, Villa of the Mysteries, Room of the Mysteries, west wall.

of Venus, who immediately bring the story into the atmosphere of myth and the divine. On the opposite wall the initiate is assisted and guided by an experienced woman; holding the sacred texts in her left hand, she listens enthralled to the formulas of the ritual, read from a papyrus by a nude boy, symbol of candor and unawareness (Fig. 99).

The rite now enters increasingly into the quick with the lustral ceremony of purification (Fig. 101). The woman, seated and crowned with myrtle, is sprinkled by an officiant with lustral water on her right hand, while with her left she uncovers the sacred objects in the basket that a maid holds out to her. Another officiant, emblematically portrayed pregnant, approaches to offer her the sacred cakes, symbol of the harvest and of the fertility of the land. At this point the scene changes and the characters of the Dionysiac procession begin to interact with the initiate, creating a complete fusion between the plane of real life and that of myth. At the sound of Silenus's lyre (Fig. 100),

98. The preparation of the bride-initiate.
Early Second Style. ca. 70–50 B.C. Pompeii. Villa of the Mysteries. Room of the Mysteries, south wall.

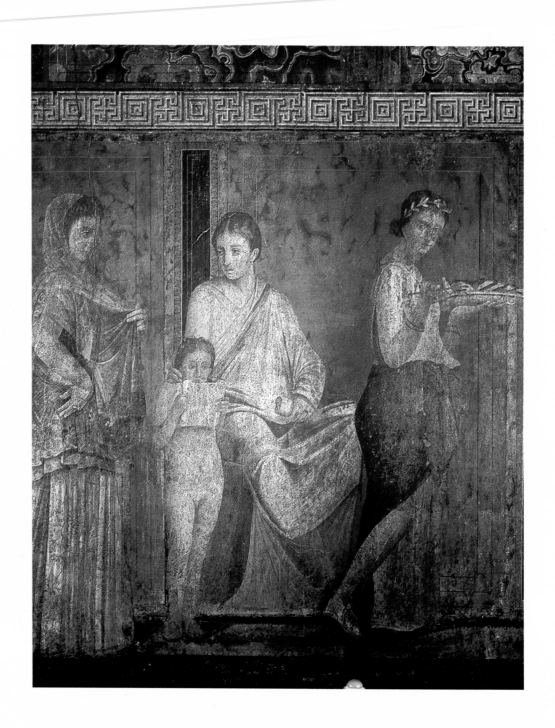

99. The reading of the ritual.
Early Second Style. ca. 70–50 B.C. Pompeii, Villa of the Mysteries,
Room of the Mysteries, north wall.

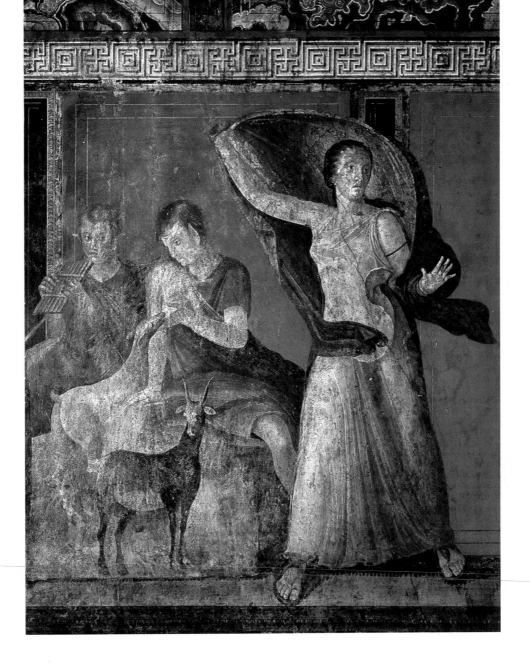

100. Maenad and *panisca* (female Pan) breastfeeding a fawn.
Early Second Style. ca. 70–50 B.C. Pompeii. Villa of the Mysteries,
Room of the Mysteries, north wall.

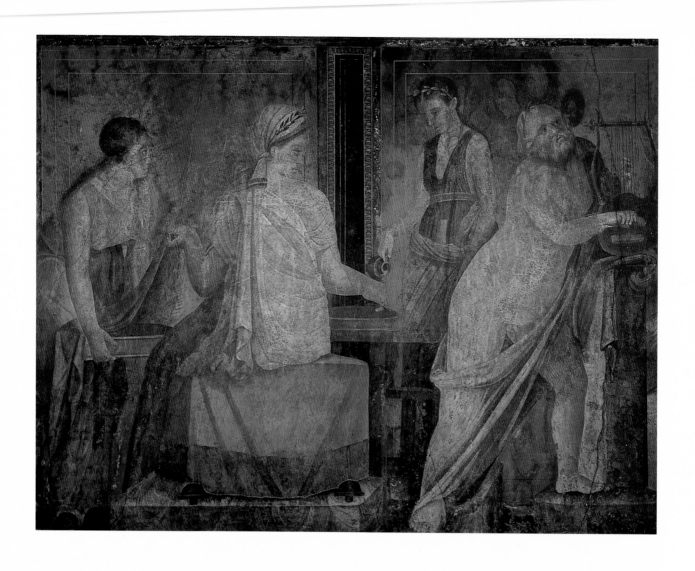

101. Scene of ritual washing.
Early Second Style. ca. 70–50 B.C. Pompeii, Villa of the Mysteries,
Room of the Mysteries, north wall.

102. Maenad in orgiastic dance and the fear of the initiate.
Early Second Style. ca. 70–50 B.C. Pompeii, Villa of the Mysteries,
room of the Mysteries, south wall.

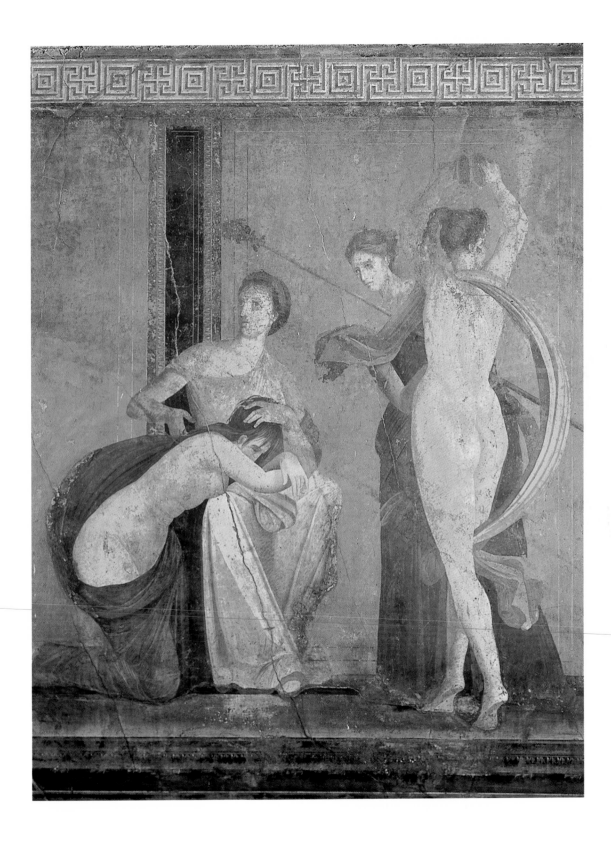

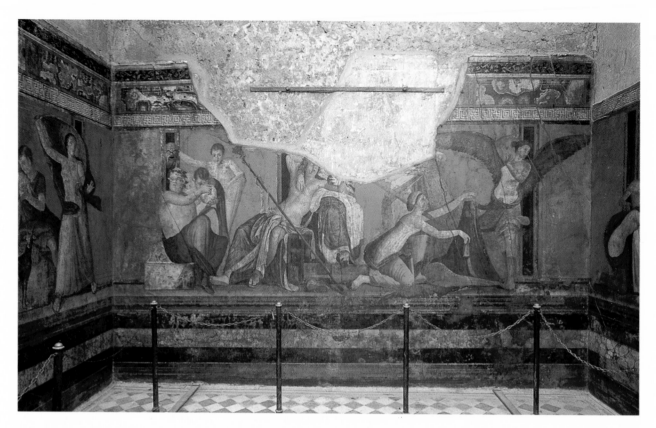

symbol of cosmic harmony, a maenad begins to sway in a dizzying dance, while in the background a *panisca* (female Pan), to the sound of Pan's pipes, breastfeeds a fawn, with clear reference to the universal love that binds all creatures.

 The rite is now almost at its climax and, on the opposite wall, a nude and possessed bacchant accompanies her dance movements with the obsessive rhythm of the castanets that she shakes above her head, while a companion holds the thyrsus, the rod of phallic symbolism sacred to Dionysus, entwined with ivy leaves and vines and terminating in a pine cone (Fig. 102). The initiate, having reached the decisive point of the rite, is seized by a moment of human bewilderment and terror and tries to withdraw, taking refuge disconsolately in the lap of her

103. The climax of the rite. In center, ecstasy of Dionysus.
Early Second Style. ca. 70–50 B.C. Pompeii, Villa of the Mysteries, Room of the Mysteries, east wall.

initiatrix. This woman, who personifies the human solidarity that reigns sovereign among the devotees of the rite, comforts the initiate, encouraging her to face the test.

On the back wall the ritual finally reaches completion. Dionysus, rapt in his own ecstasy, has put aside the thyrsus and slipped off his sandals to abandon himself to drunkenness in the arms of a woman who sits majestic in the dominant position, but whose features are lost in a lacuna. Rather than his mother Semele or bride Ariadne, she is probably Venus herself, the goddess of love (Fig. 103). At the level of the myth, Silenus, to the right of the divine couple,

104. The unveiling of the phallus.
Early Second Style. ca. 70–50 B.C. Pompeii, Villa of the Mysteries, Room of the Mysteries, east wall.

offers a satyr a cup containing the *satyrion*, the nectar that opens up the mind to the understanding of reality, while behind him another satyr, whose face displays rare expressive power, raises to his face a Silen mask to indicate the transmission of knowledge and the prophetic wisdom that the magic potion is able to offer (Fig. 105).

In parallel, at the level of reality, to the left of the divine couple, the initiate is now ready to receive the revelation. She is about to uncover the *mystica vannus* and thus gain awareness of the phallus, whose majestic form can be descried beneath the veil that covers it. Its regenerative power serves to ward off the adverse forces of nature, represented by a winged demon armed with a whip, ready to strike, but which must rather withdraw, impotent, in the phallus's presence (Fig. 104). The vision is over, the rite completed, the awareness is reached, and we return once again to observe the figure of the seated woman, the actual protagonist of the whole painting, who is initiate, priestess and *matrona* at the same time, and who seems, mystically absorbed, to return with thoughtful detachment to the memory of all those moments, alongside the entrance of her nuptial alcove (Fig. 97). This is a depiction of rare power that allows us to penetrate, albeit in a confused manner, a world from which we moderns are utterly shut out, allowing us at least to intuit sentiments and sensations whose equal we can scarcely imagine.

105. Silenus offers the *satyrion* to a satyr.
Early Second Style. ca. 70–50 B.C. Pompeii, Villa of the Mysteries, Room of the Mysteries, east wall.

CONCLUSION

The voyage just taken through those aspects of eroticism that can be recovered, within the cultural vision of the Roman world, from the exceptional evidence of an entire city, Pompeii, transferred miraculously into our own, has often led us to discover situations for us absolutely unheard of. Some things may amaze or astonish us, others make us smile. And we may never understand their true essence and the emotions they excited in men and women whose way of life was so different from our own.

Over and above the most disparate manifestations of eroticism—sometimes cerebral and sophisticated, sometimes disarmingly naïve—one thing has seemed clear. That is how, in the Roman world, love was able to encompass to the maximum, without reticence, all the earthly spirituality inherent in its nature. It managed to make the flesh the means of exaltation, rather than mortification, of the personality, placing it at the center of one's own feeling and thus blending it intimately with sentiment.

Eroticism, a direct emanation of love, has revealed itself in forms closely connected to that vision and therefore in various aspects dissimilar to those we perceive as belonging to its sphere. Nevertheless, the underlying similarities, the justifications and the aims do not really seem to have changed much over the centuries, even between two different ways of feeling. Beyond the forms, the motivations and the effects do not seem different. If we divest ourselves to the greatest extent possible of our cultural legacy and manage to reach the essence that creates the attraction between the sexes and between persons, in the most intriguing game that human nature knows, we will perceive in a pleasantly subtle manner the absolute homogeneity of the two points of view, which have remained absolutely identical after two thousand years and which, we hope, will remain so for many centuries to come.

When we understand the essence of things, we realize that schemes, mental superstructures and cultural constructions inexorably give way to genuine sentiment, which goes beyond class, caste and census, to nourish itself on spontaneity. On such spontaneity is

IF YOU CAN, WHY POSTPONE THE JOYS? AND IF YOU DON'T WANT,
WHY DO YOU FEED THE HOPE, AND PUT ME OFF TILL TOMORROW?
MAKE ME DIE THEN IF YOU MAKE ME LIVE WITHOUT YOU.
CERTAINLY, NOT HAVING PUT ME ON THE CROSS WILL BE A KIND DEED.

CIL **IV 1837**

based the erotic game par excellence, that which has always offered to humankind the most profound and perhaps also the most keenly felt and the truest impulses.

It is an ancient game, in which seduction goes hand in hand with reticence, in which granting permission to hope is closely paired with pretending to say no, in which giving and withholding are at the same moment surrender and victory together. It is a game that leaves no one unaffected and that inevitably brings erotic tension to its peak. It is a game sung and celebrated through the ages: the oft-repeated passages of Latin poetry can find echoes in the poetry of every time and of every land. At Pompeii, too, we can make a poet speak, a man who has left some of his verses on a wall telling of repeated rejections by a hesitant woman who insists on opposing his offers of love, though continuing to promise herself to him. The words are translated into the desperate melancholy of elegiac poetry (*CIL* IV 1837 with add. pp. 212, 464, 704):

> If you can, why postpone the joys? And if you don't want,
> why do you feed the hope, and put me off till tomorrow?
> Make me die then if you make me live without you.
> Certainly, not having put me on the cross will be a kind deed.

The chorus of voices from the street that join the poet, each commenting in its own way on a situation that many evidently had experienced and which does not leave anyone indifferent, show just how common this problem was at the time: "What hope takes away, hope gives back later to him who loves," "Whoever reads this must never read anything else afterwards and whoever writes over it will not be saved," "You said it," "Well said, Edisto."

It is as if we are seeing in this humble and hesitant Pompeian woman, the Galla to whom, from the cushioned Roman drawing rooms, Martial no differently says, "you are always promising it to me and you never give it to me" (II.25,1), actually remaining in the most total of the uncertainties (III.90):

Galla wants to give it to me, and she doesn't want to
nor would I know how to say what it is that she does want
seeing she wants to and she doesn't want to.

Even though he perceives the erotic charm that the situation involves, he certainly cannot do otherwise than beg (IV.38):

Galla says no. Fine: love doesn't last
if pleasure isn't matched with torture.
But, Galla, don't say no excessively!

Radiant, at this point, if compared with the position of Martial, appears the bonhomie with which another Pompeian, perhaps less gifted as a poet, but a charming rascal as a man, transports us into a situation in which the subtle game of seductive approaches on the one hand and formal reticence on the other is experienced in an atmosphere of joyous serenity. The sensuality that, as we conjecture, will manage to get the upper hand before long, lets them seep through, if only with blurred outlines, an emotion of refined, subtle eroticism, which sees in the ending the farewell with which the author now takes his leave from the reader (Giordano, *Fabio Rufo* no. 46):

Vasia quae rapui, quaeris, formosa puella;
accipe quae rapui non ego solus: ama.
Quisquis amat valeat

O comely girl, you ask me the reason
for these kisses I have stolen?
Was I only stealing? Take them, and love.
HAPPINESS ALWAYS TO THOSE WHO LOVE!

INDEX OF INSCRIPTIONS CITED

INDEX OF IMPORTANT PERSONS, PLACES AND THINGS

BIBLIOGRAPHY

Barré, M.L. *Herculaneum et Pompei.*, VIII. *Musée Secret.* Paris, 1877.

Brendel, O.J. "The Scope and Temperament of Erotic Art in the Greco-Roman World," in Bowie, T., and C. Christenson, *Studies in Erotic Art.* New York, 1970.

Cantarella, E. *Pompei. I volti dell'amore.* Milan, 1998.

Cèbe, J.P. *La caricature et la parodie dans le monde romain antique dès origines à Juvenal.* Paris, 1966.

Clarke, J.R. *Looking at Lovemaking: Constructions of Sexuality in Roman Art 100 B.C.–A.D. 250.* Berkeley-Los Angeles, 1998.

D'Avino, M. *Pompei proibita. Erotismo sacro, augurale e di costume nell'antica città sepolta.* Naples, 1993.

Dierichs, A. *Erotik in der Römischen Kunst.* Mainz am Rhein, 1997.

Fantham, E., et al. *Women in the Classical World.* New York-Oxford, 1994.

Grant, M. *Eros a Pompei. Il gabinetto segreto del Museo di Napoli.* Verona, 1974.

Jacobelli, L. *Le pitture erotiche delle Terme Suburbane di Pompei.* Rome, 1995.

Johns, C. *Sex or Symbol? Erotic Images of Greece and Rome.* Austin, 1982.

Kampen, N.B. *Sexuality on Ancient Art. Near East, Egypt, Greece and Rome.* New York, 1996.

Keltanen, M. *Kätketty rakkaus. Pompejin eroottiset seinämaalaukset.* Helsinki, 1997.

Keuls, E.L. *The Reign of the Phallus.* New York, 1985.

Krenkel, W.A. "Figurae Veneris," in *WissZRostock* 36 (1987), pp. 49-56.

Marcadé, J. *Roma Amor: Essay on Erotic Elements in Etruscan and Roman Art.* Geneva, 1965.

Marini, G.L. *Il Gabinetto segreto del Museo Nazionale di Napoli.* Turin, 1971.

Musée Royal de Naples. *Peintures, bronzes et statues érotiques du Cabinet Secret*, I-II. Brussels-Paris, 1876.

Myerowitz, M. "The Domestication of Desire: Ovid's *Parva Tabella* and the Theater of Love," in Richlin, A. (ed.), *Pornography and Representation in Greece and Rome.* New York, 1992.

Parker, H.N. "Love's Body Anatomized: The Ancient Erotic Handbooks and the Rhetoric of Sexuality," in Richlin, A. (ed.), *Pornography and Representation in Greece and Rome.* New York, 1992.

Reinach, S. *Répertoire de peintures grecques et romaines* (1922). Reprint, Rome, 1970.

Richlin, A. *The Garden of Priapus: Sexuality and Aggression in Roman Humor*. New Haven-London, 1983.

Richlin, A. (ed.). *Pornography and Representation in Greece and Rome*. New York, 1992.

Rousselle, A. *Porneia*. Paris, 1983.

Rousselle, A. "Personal Status and Sexual Practice in the Roman Empire," in Feher, M. (ed.), *Fragments for a History of the Human Body*, vol. III. New York, 1989.

Savunen, L. *Women in the Urban Texture of Pompeii*. Helsinki, 1997.

Schmitt Pantel, P. *Storia delle donne in Occidente* (G. Duby and M Parrot, eds.), vol. I: *L'Antichità*. Rome-Bari, 1990.

Varone, A. *Erotica Pompeiana. Iscrizioni d'amore sui muri di Pompei*. Rome, 1994.

Veyne, P. (ed.). *A History of Private Life*, vol. I: *From Pagan to Byzantium*. Cambridge, 1987.

Wuilleumier, P. *Les médaillons d'applique gallo-romains de la vallée du Rhône*. Paris, 1952.

Extremely interesting considerations on the topic can be read in P. G. Guzzo and V. Scarano Ussani, *Figurae Veneris. Immagini e problemi della prostituzione a Pompei*, Electa Napoli. Professor Guzzo, whom I thank, was kind enough to let me read his work in manuscript.